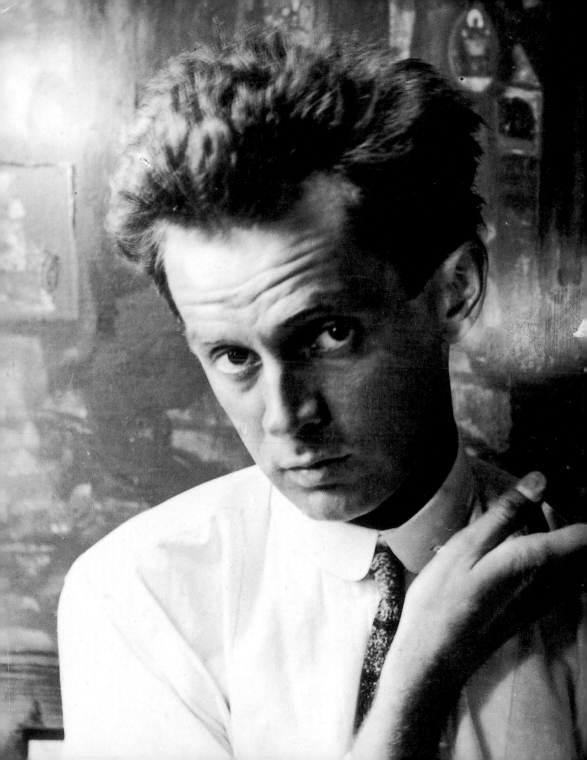

Kai Artinger

Egon Schiele

Life and Work

KÖNEMANN

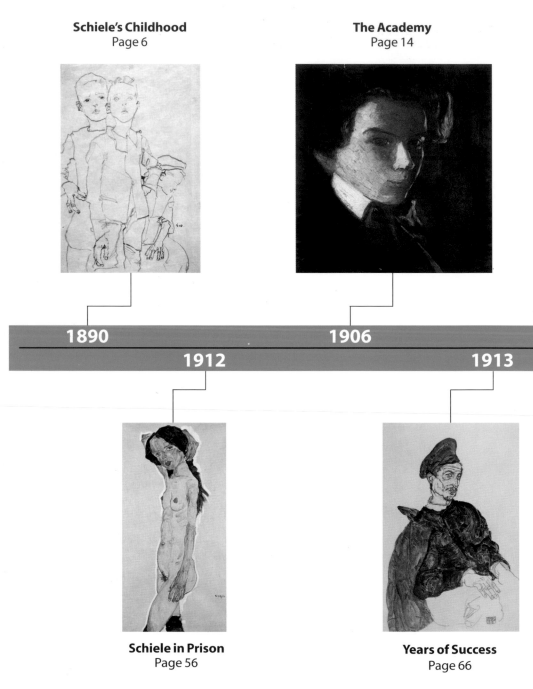

Schiele's Childhood
Page 6

The Academy
Page 14

1890

1906

1912

1913

Schiele in Prison
Page 56

Years of Success
Page 66

The Neukunstgruppe
Page 26

Krumau
Page 40

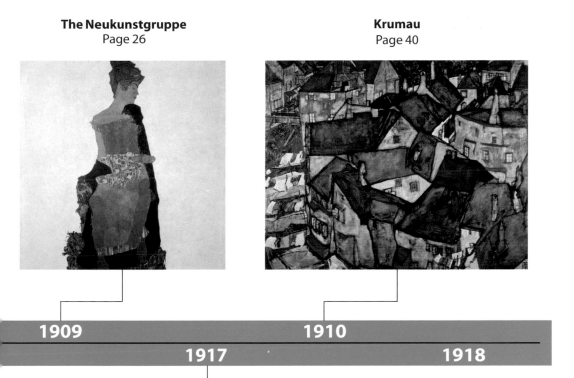

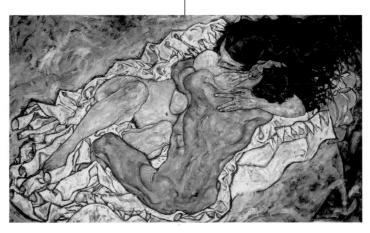

Return to Vienna
Page 76

Schiele's Childhood

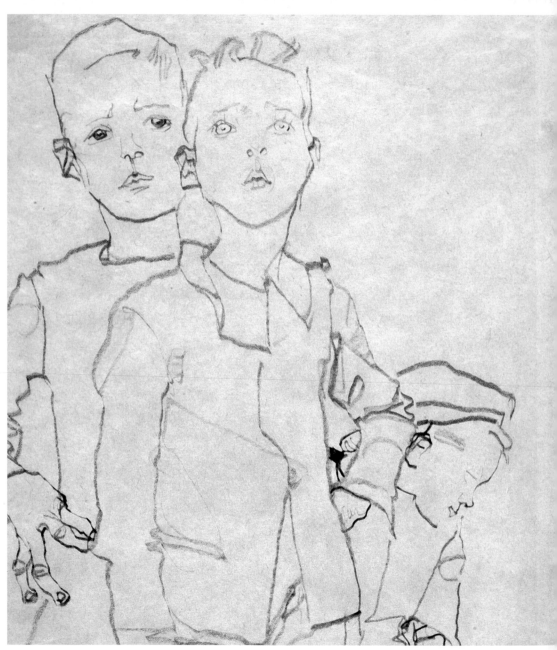

Egon Schiele was born in 1890 in a busy railroad station – his father was the stationmaster at Tulln, a small town near Vienna – and the world of railroads and steam was to shape his childhood. There was little place for art in the orderly family life of a civil servant, whose days were governed by the performance of routine duties. It was only towards the end of his schooldays that this gifted but poor pupil was assisted by teachers who provided him with a sound knowledge of painting and contemporary art. In time the boy's desire to become an artist became a firm resolve. Schiele's youth, however, was overshadowed by his father's gradual decline into madness and his early death, traumatic experiences that explain the intense, often somber mood of his works. After his father's death Schiele's uncle and guardian, Leopold Czihaczek, gave way to his ward's plan to become an artist only after Egon had been accepted as a student at the prestigious Academy of Arts in Vienna.

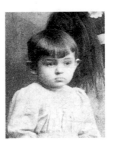

The Danube Canal in Vienna ca. 1900, with the Riesenrad in the background

Schiele ca. 1892

1893 In Vienna, more than 40,000 people demonstrate for equal and direct voting rights.

1895 Film invented.

1899 2nd Boer War between Britain and the Boer states, in which Schiele's teacher Ludwig Strauch takes part.

1900 Freud publishes his *Interpretation of Dreams.* In Vienna, women are admitted to the study of medicine and pharmacy.

1906 On April 18 an earthquake destroys large parts of San Francisco and kills 700.

1890 Egon Schiele is born on June 12 in Tulln, the fifth child of Adolf Schiele and Marie Schiele, née Soukoup.

1894 Gertrude (Gerti), Schiele's sister, is born.

1902 Schiele goes to school at the Realgymnasium in Klosterneuburg.

1905 Schiele's father dies. His uncle, Leopold Czihaczek, becomes his guardian.

1905/06 Schiele begins to paint.

1906 Schiele's teacher, his mother and his guardian, Czihaczek, support his artistic studies.

Opposite:
Three Street Urchins (detail), 1910
Drawing
44.6 x 30.8 cm
Vienna, Graphische Sammlung Albertina

Right:
Carinthian Mountain Landscape, 1905
Ink
2.1 x 6.7 cm
Vienna, Niederösterreichische Landesmuseum

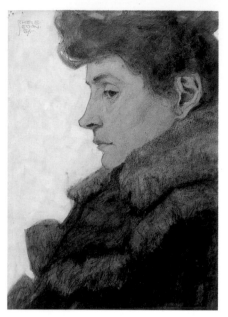

Family

Adolf Schiele (1850–1905), Egon's father, was a senior civil servant employed in the railroad department. In 1879 he married Marie Soukoup (1862–1935), who came from Krumau in southern Bohemia (then part of the Austro-Hungarian Empire) and was the eldest daughter of a rich railroad engineer. In 1877 Adolf Schiele became stationmaster at Tulln and the family, still small, moved into the staff apartment at the station. It was here, 13 years later, that Marie Schiele gave birth to Egon, her fifth child. After two still-births Marie gave birth to her daughters Elvira (1883–1893), who died when only ten, and Melanie (1886–1974). Gertrude (1894–1981) was born four years after Egon. Egon

Portrait of Marie Schiele with Fur Collar, 1907
Oil on canvas
32 x 22.3 cm
Vienna, private collection

Marie Soukoup, Schiele's mother, married Adolf Schiele at the age of 17. Her relationship with her only son was a tense one, and Egon reproached her with emotional coldness, particularly with regard to the memory of his father. For him she was a "strange person." Marie Schiele, for her part, considered him self-centered, and seems to have had little understanding of his talent.

Portrait of Leopold Czihaczek, 1906
Drawing
44.5 x 34.6 cm
Vienna, Graphische Sammlung Albertina

Leopold Czihaczek (1842–1929) was an engineer who worked on the Austro-Hungarian railroads. He possessed a considerable fortune, and was a lover of music and the theater, though he had little interest in the visual arts. During the years 1906–1909 Czihaczek allowed Egon to paint nine portraits of him.

had a particularly close relationship with his younger sister, and up to her adulthood she sat for him as a model, for nude studies among others.

The family's misfortunes began in 1902 when Adolf Schiele was forced to retire at the age of 52 because of "mental confusion." In 1904 the family moved to Klosterneuburg, where Schiele attended the local grammar school. About this time his father is believed to have burnt all the family's share certificates in the stove, and thus deprived them of their financial security. He also ordered the table to be set for an imaginary guest, who had to be treated with the utmost respect by the family. These experiences, understandably, had a profound impact on the young Schiele. His father died in 1905, and his wealthy uncle and godfather, Leopold Czihaczek, became his guardian. His relationship with his mother

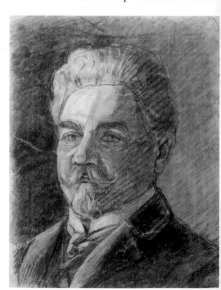

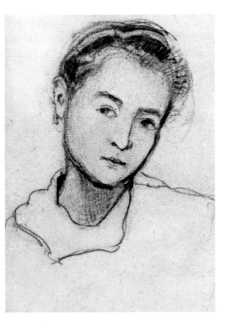

Above:
Portrait of Gertrude Schiele, 1907
Drawing
17.5 x 13.8 cm
Private collection

Schiele's sister Gertrude, known as Gertl, played a major role in Egon's life, and from around 1909/10 was his favorite model. During the years of their childhood he dominated her completely: "He drew me into everything he did, and he had a tough, almost tyrannical manner of demanding my services… He would come to my bed early in the morning, his watch in his hand, and waken me. I was to model for him, and that meant immediately." Brother and sister had an intense affection for each other, which lasted up to Egon's death in 1918.

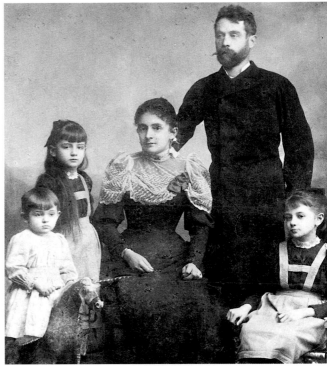

Egon Schiele (left) with his parents and his sisters Melanie and Elvira,
photograph ca. 1892

Portrait of Melanie Schiele, 1907
Drawing
45.4 x 31.3 cm
Tulln, Egon Schiele Museum

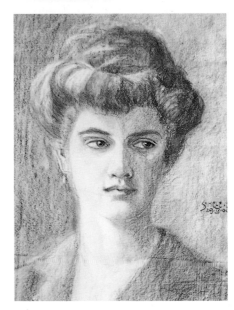

Schiele also appears to have had a close relationship with his older sister Melanie, and as a young girl she too often modeled for him.

deteriorated sharply after 1906, when he became a student at the Academy of Arts, mainly because she felt he was not doing enough to support her. Leopold Czihaczek, however, maintained a benevolent interest in his godson, and subsidized him in the manner usual in those days.

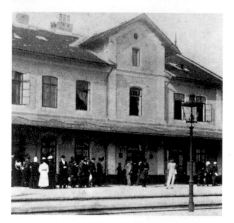

The railroad station at Tulln, photograph 1890

Egon Schiele was born in 1890, on the first floor of this house, in the last room on the right.

Egon Schiele with a toy locomotive, photograph ca. 1895

Early Works

The town of Tulln, situated 30 km (18.5 miles) west of Vienna, was of greater importance during the Austro-Hungarian Empire than its present obscurity might suggest. Its railroad station saw a high volume of passenger and freight traffic passing to and from Bohemia. During the second half of the 19th century the railroad was considered a symbol of industrialization and technical progress; it had made distances shrink and had profoundly altered the perception of time. It is not surprising that the fascinating world of the snorting steel monsters cast its spell over the young Schiele, particularly since it was his father who seemed to be in charge of this glamorous world of modern technology. Egon's favorite childhood games included playing locomotives so it is not surprising that his first drawings depict trains. "One day when he was seven," his mother related, "he sat at the window, from morning until evening, filling a thick book with drawings, getting everything down on paper, from the tracks to the signal-boxes." The eight-year-old's sketches show an astonishing

Trains, ca. 1900
Drawing
3 x 21 cm
Vienna,
Niederösterreichische
Landesmuseum

For the young Schiele the many trains he saw passing through his father's station exercised an irresistible fascination. Day after day he was able to admire and draw the most diverse types of rolling stock, and to set down on paper his detailed knowledge of the railroad. These drawings are entirely concerned with the locomotives and their carriages, and there is no sense of atmosphere or setting. The sketches depict the trains from the side and front, in order to illustrate technical differences and various designs. Egon went to a great deal of trouble in depicting the details of the engine and the tenders, and even tried to create the illusion of movement by showing the smoke and steam streaming back from the stack. With the rolling stock, by comparison, he restricted himself to simple outline drawing.

precision in technical details and a highly developed sense of draftsmanship (below); he was fully aware, for example, that shading created a sense of spatial volume. But as his talent developed over the years, his parents showed little understanding of his desire to be an artist; in fact, they actively objected to it and even tried to discourage him, burning some of his drawings in the stove.

Although Egon wandered for hours with his sketchbook and pencil, he rarely put down on paper his impressions of Tulln and later of Krems, where he lived in 1901 and where he attended the local school. Only a few watercolor views of both towns – copied from postcards – have been preserved. His preoccupation with landscape and townscape began only during his later schooldays, at Klosterneuburg, where he came under the influence of the drawing teacher, Ludwig Strauch. This was also the time of Egon's first encounter with avant-garde art, when his teacher Max Kahrer, who greatly encouraged his artistic education, introduced him to the works of the Vienna Secession.

View from the Drawing Studio at Klosterneuburg, 1905
Watercolor
36.8 x 46.1 cm
Vienna, Niederösterreichische Landesmuseum

The Forge at Klosterneuburg, 1905
Watercolor, gouache, and pencil
14.9 x 28.5 cm
Private collection

The townscapes of Klosterneuburg that Schiele painted in watercolor in his last year at school clearly illustrate his artistic ability. A difficult technique requiring considerable maturity, watercolor painting involves the ability to observe a scene's features accurately and then to set them down precisely; a confident but sensitive handling of the brush is essential. *The Forge at Klosterneuburg* is an example of the skill already acquired by Schiele. While this work impresses through its detail, its precise handling, and its treatment of light, in the *View from the Drawing Studio at Klosterneuburg* (above) Schiele succeeded in expressing an atmospheric mood.

This is how a relative described the fourteen-year-old boy: "Whenever he was free to do so, he would go out to the fields or the stream or the woods, making drawings with colored pencils on page after page of his sketchbook. In the evenings, quietly and unobtrusively and without saying very much, he would show his work to others. They were well-drawn impressions of nature, trees in sunlight… His personality at that time was subdued. His face was thin and serious, with dark eyes that could gaze ahead with a strangely calm expression. His thick black forest of hair was combed back like a mane... he was generally treated with admiration and wonder by his family."

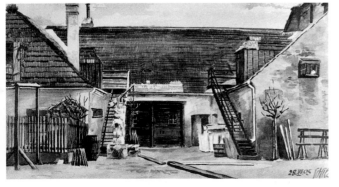

Vienna at the Turn of the Century

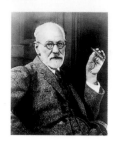

Sigmund Freud, 1926

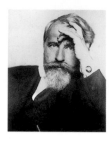

Arthur Schnitzler, 1915

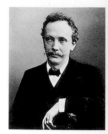

Richard Strauss, ca. 1906

At the end of the 19th century, Vienna, with four million inhabitants, was the fourth largest metropolis in Europe and the capital of the dual monarchy of Austria-Hungary, the empire of the Habsburgs. This empire, which stretched from the Adriatic right through Europe as far as the Ukraine, and had 46 million subjects, was one of the greatest in the world. But precisely because of its extent it had become a melting pot for a number of widely varying cultures, and during the 19th century the stability of its monarchy was threatened by the independence movements of various ethnic groups. The differences of culture and race within Austria-Hungary were most apparent in Vienna, whose citizens came from every corner of the empire.

It was in Vienna that the Academy of Sciences and the Academy of Arts were based; but the many scientific societies and research establishments, as well as the great art collections in the museums, also helped to confirm the reputation of the city as a major intellectual and cultural center. This attracted many notable painters, architects, writers, and musicians, who in turn further enhanced the city's cultural life.

The rapidly changing social and political conditions in Vienna provided the background for the discussion of human life in existential

The pioneering research into the unconscious carried out by Sigmund Freud (1856–1939) helped to create a new and deeper understanding of the human psyche. Principally, Freud established the unconscious as a vital force in our lives, far more powerful than the conscious mind. It was on this basis that he developed psychoanalysis.

In his plays, which deal with the basic motivating forces in people's lives, the writer and physician Arthur Schnitzler (1862–1931) dissected Viennese society at the turn of the century. Among his achievements as a novelist was his pioneering of the narrative technique of the interior monologue. His celebrated play *Der Reigen (La Ronde)*, first performed in 1903, caused a scandal and became the subject of a court case, as it dealt with a series of sexual encounters at all levels of Viennese society.

Richard Strauss (1864–1949) was the director of the Vienna State Opera from 1919 to 1924. He was among those who initiated the Salzburg Festival, which he also conducted in 1922. His collaboration with the poet Hugo von Hoffmannsthal and the writer Stefan Zweig was fruitful. *Elektra* (1909), *Salome* (1905), and *Der Rosenkavalier* (1911) are just three of the numerous compositions that made them known throughout the world

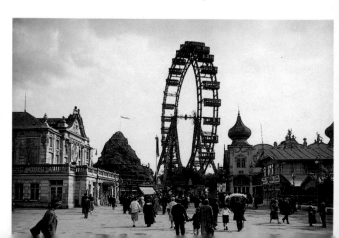

Gustav Mahler, 1907

One of the leading composers of his day, noted in particular for his symphonies and song cycles, Gustav Mahler (1860–1911) studied music at the Vienna Conservatory. During the years 1897–1907 he was director of the Vienna State Opera and between 1898 and 1901 of the Vienna Philharmonic. The orchestral discipline introduced by Mahler and the strict fidelity of his interpretations set a decisive standard in orchestral work. He also reformed opera, bringing about a new unity of production, décor, and musical interpretation.

Opposite:
Vienna at the turn of the century,
photograph ca. 1900
The Riesenrad (Giant Wheel) built in 1896/97 in the Prater, the city's best-known park, remains to this day one of the great sights of Vienna.

Theodor Herzl, ca. 1900

After following the Dreyfus affair in France, the journalist Theodor Herzl (1860–1904) came to the conclusion that the Jews were a nation and needed their own Jewish state. This idea, formulated in his book *The Jewish State* (1896), provided the stimulus for the creation of Zionism. This was also Herzl's reaction to the anti-Semitism that was then increasing in strength – in 1884, for example, self-declared anti-Semites had been admitted to parliament in Vienna.

Right:
Houses in the Wienzeile, District VI,
photograph ca. 1900
Built by Otto Wagner (1841–1918) in 1898/99, the buildings in the Wienzeile demonstrate the architecture of the Jugendstil (Art

Adolf Loos, ca. 1930

The architect and designer Adolf Loos (1870–1904) exercised a profound influence on modern architecture. The so-called Chicago School of architecture provided decisive stimulation for his own work, in which he increasingly dispensed with the customary ornamentation in building design. His house on the Michaelerplatz in Vienna became celebrated, though its functionalism and starkness of form aroused vehement protests. He also designed interiors and furniture.

Nouveau), with its ornamentation and floral decoration. Wagner, an important pioneer of modern architecture, also designed the Vienna Post Office Savings Bank (1906), one of the most original buildings of its time.

terms. Nowhere else in Europe, for example, was there such intensive preoccupation with human sexuality. Thus the physician Sigmund Freud was working on his theories of sexuality, among other topics, while in his plays and novels the writer Arthur Schnitzler presented sexuality as one of the most important sources of human motivation. The sexual element also played a great part in the Jugendstil (Art Nouveau) art of the painter Gustav Klimt, which enjoyed an international reputation.

Vienna was in bloom – but for the last time. After World War I the Habsburg empire would disintegrate.

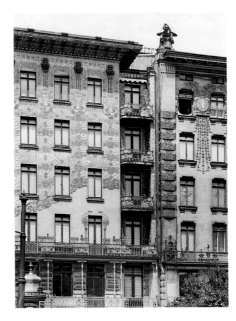

The Academy

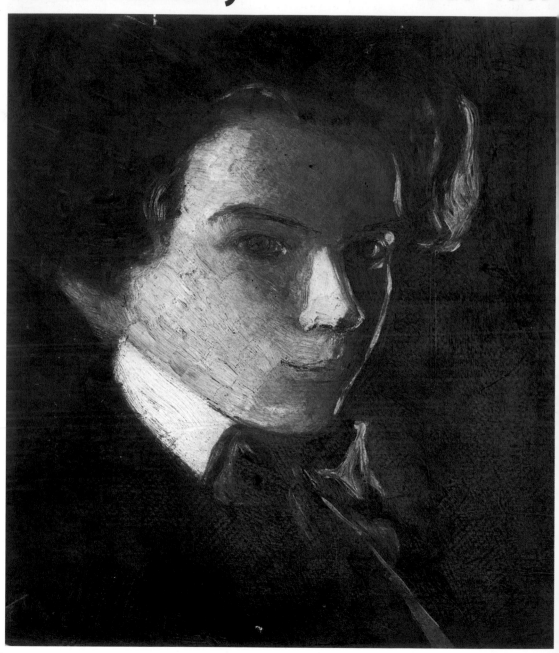

At the age of 16, Egon Schiele was accepted as a student at the Vienna Academy of Arts. He had hoped that his training would provide him with the technical skills of the various crafts and initiate him into the mysteries of art. But reality proved rather sobering: during the first period of his studies at the Academy he was allowed to paint and draw only "after the classical model." In view of this tedious program, Schiele soon lost interest and looked for exemplars outside the Academy. He started to explore the Impressionist style and also haunted the coffee-houses, where he made contact with like-minded members of the Vienna art world. His encounter with the artist Gustav Klimt was a key experience, Klimt's work having a profound influence on his development. It was an influence, however, that Schiele quickly left behind, for he soon developed his own highly distinctive artistic identity.

In 1909 Robert Peary becomes the first person to reach the North Pole.

1906/7 Picasso paints *Les Demoiselles d'Avignon.*

1908 Austria-Hungary annexes Bosnia and Herzegovina. The Olympic Games are held in London. The first Ford Model-T is built in Detroit, USA.

1909 Jewish settlers establish the first kibbutz in Palestine.

Schiele as a student at the Academy, 1908

1907 Schiele moves into his first studio in Vienna, at No. 6 Kurzbauergasse.

1908 Schiele takes part in his first public exhibition, in the Kaisersaal of the monastery of Klosterneuburg.

1909 Schiele leaves the Academy.

Opposite:
Self-Portrait Facing Right, 1907
Oil on cardboard
32.4 x 31.2 cm
Private collection

Right:
The Academy of Fine Arts, Schillerplatz, Vienna, a drawing from one of Schiele's sketchbooks.

Professor Christian Griepenkerl, photograph 1906

Schiele attended the drawing class of Professor Griepenkerl (1839–1916), an exceptionally conservative teacher, who was famous for his portraits, history paintings, and murals. Griepenkerl, who had been teaching since 1884, demanded technical perfection; he had little interest in individuality and originality. The relationship between Schiele and Griepenkerl was, inevitably, very poor. On one occasion the exasperated professor is said to have exclaimed: "The devil must have crapped you into my

class!" Schiele's work even provoked Griepenkerl to plead: "For God's sake don't tell anyone you studied under me."

Schiele and Academy students, photograph 1900

Schiele is second from the right in the back row.

Academic Training

In the early 20th century, art was no longer considered a craft, and anyone who wished to make it his career had to attend an academy. In 1906 Schiele successfully took the entrance examination for and was accepted by the prestigious Vienna Academy of Fine Arts. On moving to Vienna he probably lived first at his uncle's in the Zirkusgasse, quite near the Academy. The training of a student at the Academy was determined by a program that had been employed there for 200 years. Schiele's enrolment papers issued by the Academy state: "The subjects in the general school of painting are: 1. Drawing and painting after the classical model; 2. Drawing and painting from the human figure; 3. Drawing of nude subjects […]; 4. Studies of drapery; 5. Studies in composition." In keeping with classical art theory, the emphasis of the course of study was laid squarely on drawing, which formed the foundation of the course, along with the copying of old masters and classical works of art. Anatomical drawing and the study of perspective and light were further important elements. The students gradually worked their way up in the study of classical models and in posed models in life classes, with the nude seen as the most demanding (and most important) part of their education. Schiele entered the class of Professor Griepenkerl, a teacher typical of his time, who gave great weight to technical skill. This form

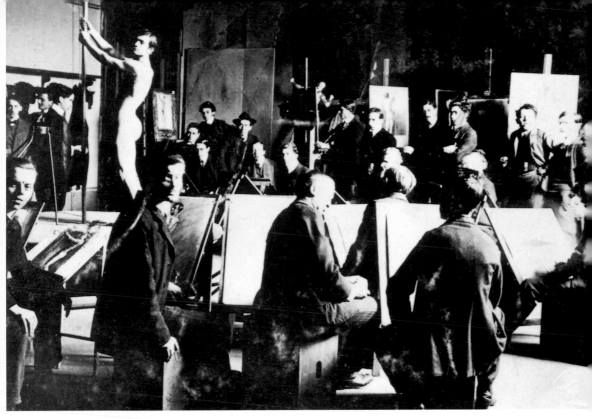

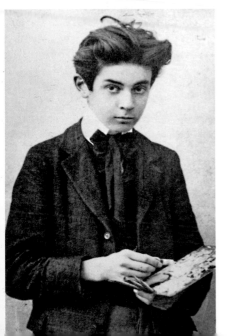

of teaching, inevitably, appealed very little to Schiele. A photograph has been preserved that shows Schiele in the life class (above). The intensive study of the unclothed body had been considered the basis of art education since the foundation of art academies in the late 16th century – women were not admitted to the Vienna Academy precisely because it was unthinkable that they should enter the life class. This taboo was not relaxed until after World War I, when the old order, artistic as well as political, finally collapsed.

Life class at the Academy of Fine Arts, photograph ca. 1906/07

Schiele is standing in the background, left, next to the man wearing a hat.

Left:
Egon Schiele, at the age of about 16, with a palette in his hand, photograph 1906

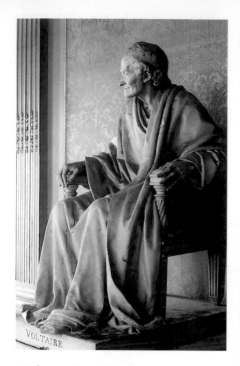

VOLTAIRE

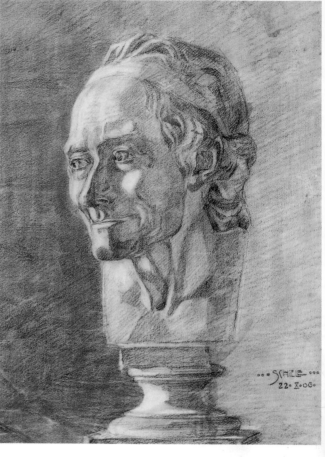

SCHIELE
22. X. 06

Classical Studies

In studying classical antiquity, Academy students were expected to become familiar with the classical sculptures and buildings that had for generations corresponded with the humanist ideal of education. Classical sculptures were of particular importance, for it was believed that they embodied the ideal proportions of the human body. In classical Greece, the beautiful had been equated with the divine; the task of sculpture was to express this concept in statues that gave "ideal" (beautiful) proportions to the body; the body depicted this way thereby became an expression of the divine. Later, academies throughout Europe

Left:
Jean-Antoine Houdon
Statue of Voltaire,
1781
Marble
Height 130 cm
Paris, Comédie
Française Collections

Jean-Antoine Houdon
(1741–1828) was one
of the most important
sculptors in France
during the second
half of the 18th
century. His statues
and portrait busts

bear witness to a
classical concept of
art, but are
distinguished by keen
observation and lively
composition. Among
Houdon's most
famous works is this
statue of Voltaire,
completed in 1781, a
telling image of the
philosopher of the
Enlightenment as a
man of reason and
humane good sense.

Bust of Voltaire, 1906
Drawing
52.5 x 37.8 cm
Vienna, Graphische
Sammlung Albertina

In this drawing the
subject (Houdon's
portrait of Voltaire) is
not given a personal
interpretation: Schiele
keeps strictly to his
model. Cleanly
executed shading and
white highlights bring
out the clearly defined
profile of the head.

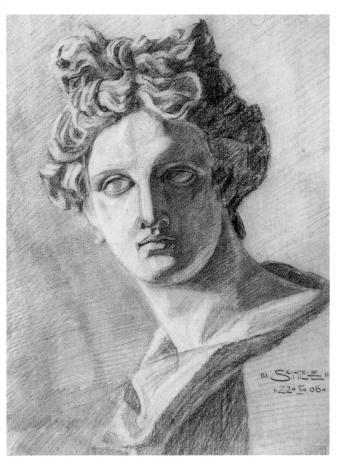

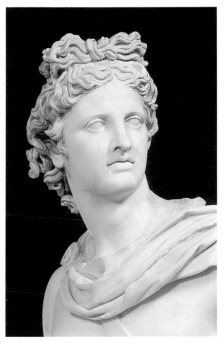

Head of Apollo, 1906
Drawing
53.5 x 37 cm
Vienna, Graphische
Sammlung Albertina

Here Schiele left the parts of the face on which light fell largely untouched, while indicating areas of shadow with a delicate cross hatching that creates a range of subtle tones. This rendering of light and shadow, which makes the head appear as if in a shaft of light, gives the drawing a strongly sculptural quality. Although Schiele kept closely to his model (right), his study appears more "feminine" than the original because of his emphasis on the oval shape of the face, the slender nose, and the rather high hairline.

Right:
Head of the Apollo Belvedere,
ca. 330/20 BC, Roman copy
Marble
Height 2.24 cm
Rome, Vatican Museum

This statue of Apollo may be derived from a work by the Greek sculptor Leuchares (ca. 370–325 BC).

taught the classical ideal of beauty (though not the religious values associated with it), and made the copying of plaster casts of classical sculptures an essential component of artistic training. As a result, the novice had to concentrate first on the drawing and painting of hands, feet, individual features of the face, then on heads, and finally complete bodies. Even at progressive academies, where the elementary instruction had been curtailed, the copying of sculptural heads and parts of the body was considered fundamental. Schiele's work during his first year of study shows that the imitation of classical works took up a great deal of his time.

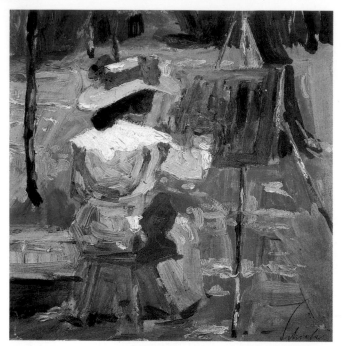

Landscape and the Influence of Impressionism

The Academy of Arts had no influence on Schiele's development as a painter – freestyle painting was not taught there, and Schiele had finished his studies as early as 1909 and so was not trained in traditional techniques. He continued his studies on his own and experimented with the various styles that were seen as progressive at the time, notably Impressionism. Ten years earlier Impressionism had helped to bring about the foundation of the Vienna Secession, for Impressionist painters had been barred from exhibiting at the official Künstlerhaus and had formed their own group. From its first exhibition in 1898 until it split in 1905, the Vienna Secession brought modern art to Vienna in almost two dozen exhibitions and contributed to the spread of Impressionism and Post-Impressionism in Austria. For young artists it was therefore an obvious first step, in their search for a personal style, to become familiar with these contemporary artistic developments. Like the Impressionist, Schiele took his easel into the countryside and painted scenes from nature. His palette now included brilliant colors, and his approach to the application of paint was entirely unacademic. Through such studies in the Impressionist style Schiele was able to perform artistic experiments quite unthinkable at the Academy.

Above:
Woman Painting,
1907
Oil on card
27.3 x 25.5 cm
Private collection

In this small oil sketch Schiele was trying to capture the essentials of the scene with short, rapid brushstrokes. The color is applied broadly and thickly, three-dimensionality being created by means of the spots and dabs of bright color. These highlights are used to define the features of the woman's dress, and to indicate flecks of sunlight on the meadow, easel, and stool. The subject of a woman painting was a popular motif among the Impressionists, particularly Claude Monet (above).

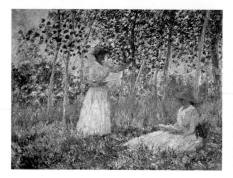

Claude Monet
Suzanne and Blanche Hoschede,
Undated
Oil on canvas
97 x 130 cm
Private collection

Suzanne and Blanche were the daughters of Monet's second wife.

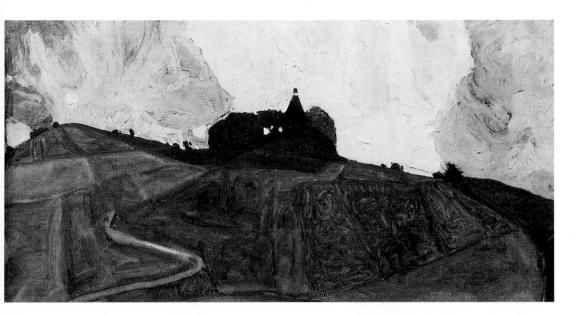

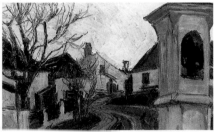

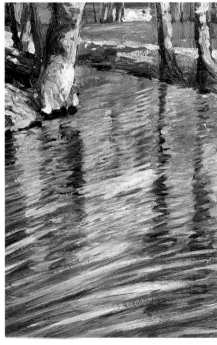

Top:
Stormy Mountain,
1910
Oil on canvas
35.2 x 65.7 cm
Switzerland,
Weinberg Foundation

At this stage, the style
of Schiele's paintings
can be seen as "late
Romantic-academic."
He had a preference
for wide and
uneventful
foregrounds.

Above:
**Bare Trees, Houses,
and Wayside Shrine
(Klosterneuburg)**,
1908
Oil on card
15.5 x 25.5 cm
Vienna, private
collection

As a student, Schiele
painted
Klosterneuburg
several times, his
paintings revealing a
keen eye for detail.

Right:
**Pond with Reflected
Trees**, 1907
Oil on cardboard
30.5 x 19.7 cm
Private collection

The theme and details
of this small oil
painting are typical of
Impressionist
painting. The picture
appears to capture an
arbitrary detail, like a
snapshot. The work is
a study in light and
movement, with
densely placed,
curved brushstrokes
creating a feeling of
movement and
unrest.

Gustav Klimt, Friend and Mentor

Gustav Klimt (1862–1918), the chief representative of Vienna Jugendstil, was one of the most important decorative painters of the 20th century. His work, which stresses surface values in a radical manner, is not only a synthesis of Impressionism and Symbolism, but also a forerunner of abstract art. At the Vienna School of Arts and Crafts, Klimt studied under the most important representatives of decorative painting in Vienna. In 1894 he turned away from the academic tradition and became the spokesman of the young, dissenting generation of artists; in 1897 he was elected as the first president of the newly formed Vienna Secession. His murals for the New University of Vienna, first shown to the public in 1900, aroused violent criticism on account of their eroticism – Klimt's paintings often scandalized public opinion. His work was rejected by leading members of the art establishment, but was enthusiastically received by young artists and intellectuals. His paintings are characterized by a new, highly ornate style in which realistically reproduced details such as hands and faces are combined with abstract, colorful, mosaic-like surface patterns. Geometric patterns cover the whole picture and allow the naturalistically painted physical details to emerge only here and there. This contrast between surface and form – between the decorative patterns, which are often silvered or gilded, and the sensual and often erotic details – greatly heightens the impact of the paintings. His works made him the most sought-after portraitist of fashionable Vienna, and he became an inspiration for young artists such as Oskar Kokoschka and Egon Schiele. Nevertheless, Klimt's elaborate style was not really "modern"; it remained in essence a product of the *fin de siècle* mood of the late 19th century.

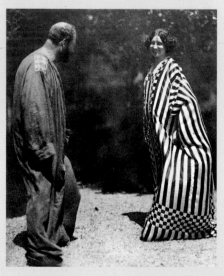

Gustav Klimt and Emilie Flöge at the Attersee, photograph ca. 1905–06

Chronology

July 14, 1862 Klimt is born at Baumgarten, near Vienna.

1876–82 Studies at the School of Arts and Crafts, Vienna.

1879 Works with the historical painter Hans Makart (1840–1884).

1883 With his brother Ernst and Franz Matsch, opens a studio for mural decoration, the Künstlercompagnie (Society of Artists).

1890 The Künstlercompagnie paints the stairwell of the Kunsthistorischen Museum (Art-Historical Museum), Vienna.

1894 Kilmt turns to a new, decorative style featuring highly ornamented surfaces.

1897 Foundation of the Vereinigung Bildender Künstler Österreich (Union of Visual Artists of Austria), known as the Vienna Secession. Klimt becomes its first president.

1900 Submits designs for a competition for paintings for the New University of Vienna, but fails to win the commission.

1902 His *Beethoven Frieze* (the paintings he created for the Secession House to complement Max Klinger's Beethoven sculpture) is rejected.

1903 Visits Ravenna, where the early Christian mosaics make a lasting impression on him, influencing his "golden style."

1905 Resigns from the Secession.

1909 Oskar Kokoschka and Egon Schiele exhibit their works at the second Kunstschau, the last exhibition organized by Klimt.

1910 Klimt takes part in the Venice Biennale.

1911 Designs the ornamental frieze for the Palais Stoclet in Brussels.

1917 Klimt's application for a professorship at the Vienna Academy is not taken up, but he becomes an honorary member of the Vienna and Munich Academies.

1918 Becomes ill with Spanish influenza and dies on February 6.

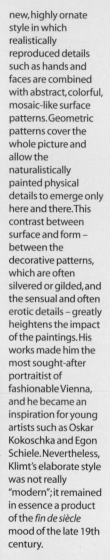

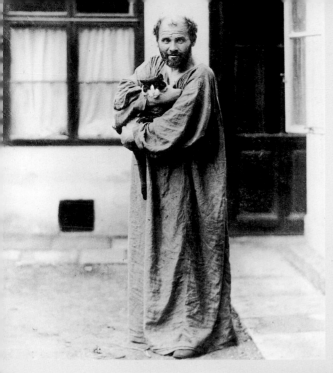

Left:
Gustav Klimt, photograph ca. 1912, taken at his studio in the Josefstädter Strasse, Vienna

Klimt made a name for himself as a painter of beautiful women, and his affairs with several of his models were the talk of Vienna. Many of his portraits of the ladies of the "Viennese financial aristocracy" have survived, as have many thousands of erotic drawings, which are remarkably explicit. It has long been assumed that Klimt chose his models from the lower levels of society, and had sexual relations only with them, while his relationship with his lifelong companion Emilie Flöge, the daughter of a very wealthy family, was of the purely platonic kind. He was clearly fascinated by the riddle of the sensually erotic woman, and became famous for his images of the *femme fatale*, the "woman who plays with fate," his ideal of femininity being characterized by a frank, self-conscious eroticism.

Right:
Gustav Klimt
Adele Bloch-Bauer I, 1907
Oil on canvas
138 x 138 cm
Vienna, Österreichische Galerie

Like a bust, and with almost photographic precision, the subject's head emerges from a confusing carpet of ornament. The garment has no sculptural quality; it is an abstract design of patterns and geometric shapes. Dress and ornamentation are inextricably linked and blend into the ornate background. The artist has dispensed with empty space. The entire treatment of the surface is designed to convey an impression of splendor and luxury. The use of the square format was very popular during the Jugendstil period. Adele Bloch-Bauer, the scion of a banking family, was the wife of the much older Ferdinand Bloch, a sugar producer. The couple collected works by Klimt.

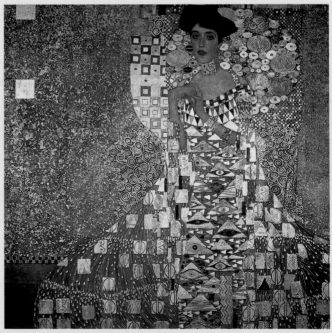

The Influence of Klimt

Schiele met his mentor for the first time in 1907, in the Café Museum in Vienna. Klimt's personality impressed him no less than his painting, which to Schiele stood for modernity and progressiveness. But the two men had something else in common: they were both fascinated by the naked body and human sexuality. Klimt, recognizing Schiele's exceptional talent, took the younger man under his wing. He supported him by buying his drawings, providing him with models, and introducing him to potential patrons. Toward the end of 1908 he enabled Schiele to work at the Wiener Werkstätte (Vienna Workshop). This had emerged as an offshoot of the Vienna Secession, having been founded in 1903 by the architect Josef Hoffmann. This new institution was based on the idea of the *Gesamtkunstwerk*, the "total work of art" that embraced several arts. Art was no longer to be limited to a specific, rather narrow, sphere but to be allowed to exert a creative influence on daily life. The Wiener Werkstätte was responsible for the design and production of craftworks, and produced clothing, household goods, and furniture. Schiele designed postcards and men's fashions for the Werkstätte; his postcard designs show the pronounced influence of Klimt. It was probably because of the latter's patronage that in 1909 he was able to exhibit four paintings at the

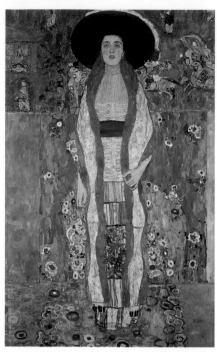

Gustav Klimt
Adele Bloch-Bauer II, 1909
Oil on canvas
190 x 120 cm
Vienna, Österreichische Galerie

This second portrait of Adele Bloch-Bauer was painted two years after the first one (page 23). She was the only lady in Viennese high society who could claim to have been immortalized twice by Klimt.

Gustav Klimt
Danae, 1907–08
Oil on canvas
77 x 83 cm
Vienna, Sammlung Dichand

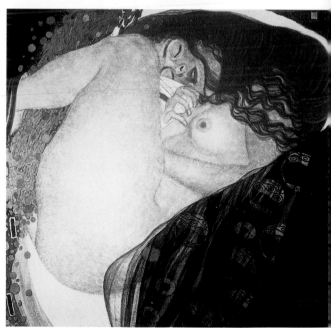

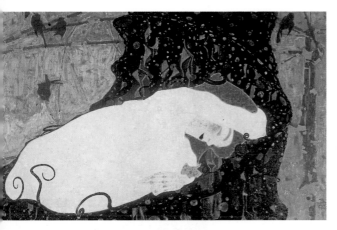

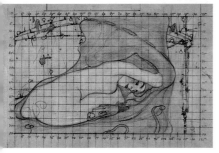

Left:
Study for Danae,
1909
Chalk on paper
30.6 x 44.3 cm
Vienna, Graphische
Sammlung Albertina

Danae, 1909
Oil on canvas
80 x 125 cm
Vienna, private
collection

In classical
mythology, Danae
was imprisoned in a
chamber by her father
because of a
prophecy that his
death would be
brought about by his
daughter's son.
Schiele's Danae lacks
the eroticism of
Klimt's earlier version
(opposite); she
appears cocooned
and solitary. Klimt's
Danae, by contrast,
though sleeping,
seems to be waiting,
and displays her
physical charms.

**Portrait of a Woman
in a Black Hat**, 1909
Oil with gold and
silver leaf on canvas
100 x 99.8 cm
Switzerland, Georg
Waechter Memorial
Foundation

The model for this
painting was Klimt's
Bloch-Bauer II
(opposite, top). The
surface quality and
costly texture of the
dress are reminiscent
of Klimt, but the pale,
unornamented
background is
Schiele's own idea.
While Klimt's subject
simply stands quietly,
Schiele's is caught in
an expressive gesture.

Kunstschau, the exhibition put on by
the artists who had broken away
from the Vienna Secession in 1905.
He found himself in distinguished
company: apart from Klimt, other
exhibitors included Edvard Munch,
Henri Matisse, Pierre Bonnard,
Oskar Kokoschka, Vincent van Gogh
and Paul Gauguin. During this period
Schiele was still under the direct in-
fluence of Klimt, as can be seen in
two of his exhibited paintings,
*Portrait of a Woman in a Black
Hat* (right) and *Danae* (above). Later
Schiele explained this intensive pre-
occupation by saying that he had
to "go through Klimt" in order to
find himself.

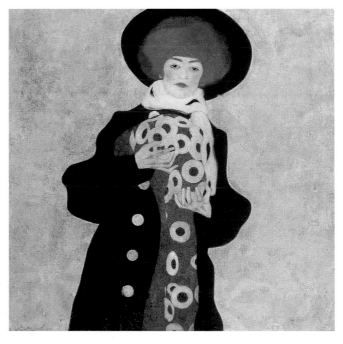

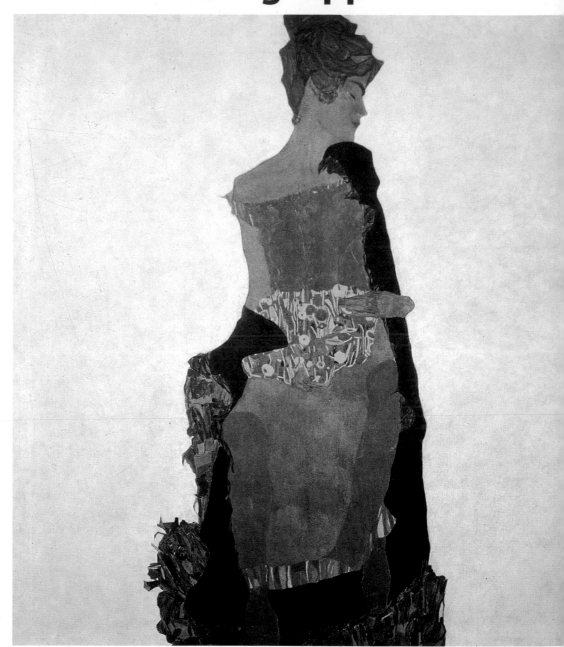

The year 1909 saw several turning-points in Schiele's life. On leaving the Academy of Arts he took his first confident step into an uncertain future: he became a professional artist. Together with like-minded colleagues he founded the Neukunstgruppe (New Art Group), and at the end of the year, as its president, he organized the first group exhibition, which proved to be a major event. The show had no financial success and only limited public appeal, but Schiele attracted the interest of several influential personalities. His uncle, however, growing tired of his nephew's bohemian lifestyle, relinquished his guardianship in 1910, so that Schiele now had to become financially independent. In the same year he also freed himself stylistically from the influence of Klimt. In particular he abandoned the two-dimensional structure of the image in favor of the angular line that was to become the characteristic feature of his work. In contrast to the refined eroticism of the Jugendstil, Schiele was to develop a new theme: sexuality as an existential human impulse.

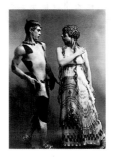

The Ballets Russes appear in Paris for the first time

1909 Foundation of the Neuen Künstlervereinigung Münchens (New Union of Artists, Munich). Invention of the first synthetic material, Bakelite. Louis Blériot flies across the English Channel from Calais to Dover in 27 minutes.

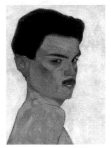

Self-Portrait (detail), 1909

1909 Foundation of the Neukunstgruppe (New Art Group), who hold a group exhibition at the Galerie Pisko. Schiele meets the critic Arthur Roessler and the collectors Carl Reininghaus and Oskar Reichel.

Opposite:
Portrait of Gerda Schiele, 1909
Oil on canvas
140.5 x 140 cm
New York, Museum of Modern Art

Right:
Klimt and Schiele, 1909
Black ink and wash
15.5 x 9.9 cm
Vienna, Graphische Sammlung Albertina

Beginnings at the Salon Pisko and Other Exhibitions

In order to satisfy his need to succeed as a "renewer" of art, Schiele sought to confront the public directly, and so took a very active role in organizing exhibitions; this was in part based on his ambition to emulate Klimt, who had instigated the Kunstschau. The exhibition at the Salon Pisko by the Neukunstgruppe, a group founded by Schiele and like-minded artists, was a success with the public. Even the heir to the throne, Archduke Franz Ferdinand, was among the visitors, though the pictures were not to his taste! "No one must know that I have looked at this muck," he is said to have remarked. Schiele also prepared a manifesto for the group, in which he wrote: "The New Artist is and must unconditionally be himself, he must be a creator, he must be able to lay new foundations directly and on his own, without making use of everything that is in the past or dragged in from elsewhere."

Exhibitions were vitally important because they brought new art to a wider public and also helped to sell it. Since in Vienna at that time young, unknown painters had very few opportunities to exhibit, it is all the more remarkable that the gallery owner Gustav Pisko took a considerable financial risk with the Neukunstgruppe. It was only in 1918 that Schiele once again had the chance to organize art shows. The

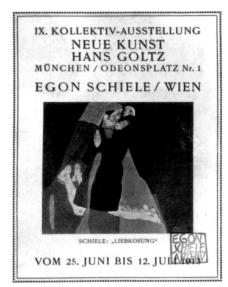

IX. KOLLEKTIV-AUSSTELLUNG
NEUE KUNST
HANS GOLTZ
MÜNCHEN / ODEONSPLATZ Nr. 1
EGON SCHIELE / WIEN

SCHIELE: „LIEBKOSUNG"

VOM 25. JUNI BIS 12. JULI 1913

Poster for Schiele's Exhibition at the Hans Goltz Gallery in Munich, 1912
Vienna, Graphische Sammlung Albertina

The poster shows Schiele's painting *Cardinal and Nun* (page 65). Goltz managed to sell only black and white drawings; the paintings in the exhibition found no buyers. Since Goltz had no confidence in Schiele's future, he extracted himself from the contract with the artist. In a letter of April 1913 Goltz declared that "isms" (Impressionism, Expressionism, Cubism, and so on) were necessary as paths towards a new art, but that now a "calm, powerful art" should take their place. Otherwise, he goes on to explain, the art dealer, for all his personal commitment, would not be able to sell any works. "I only want to prepare you for total financial disaster, which must befall your endeavor at the present stage of your development," warned Goltz, who sensed that even those sections of the public that were sympathetic to "wild" Expressionist painting were beginning to weary of it.

Below:
Exhibition Poster for Galerie Arnot, Vienna, 1915
Vienna, Historisches Museum der Stadt Wien

Here Schiele offers a stylized version of himself in the guise of St. Sebastian – as a misunderstood genius tortured by a malevolent public.

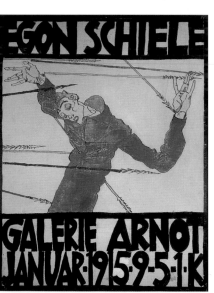

EGON SCHIELE

GALERIE ARNOT
JANUAR·1915·9·5·1·K

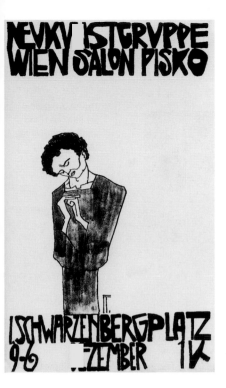

Anton Faistauer
Poster for the Exhibition of the Neukunstgruppe, 1909
48 x 28 cm

The poster for the Neukunstgruppe (New Art Group) is a vivid assertion of its desire to create a progressive art. As this poster shows, the group's move away from the elegant Jugendstil is evident; Faistauer restricted himself to a minimal design, from which decorative lines and ornament have been purged. The simple form of the figure and its meditative attitude, as if lost in prayer, represents an introverted concept of art that expressly rejects any connection with the Jugendstil.

Below:
The Pisko art gallery, photograph 1909
Alessandra Comini

The Galerie Pisko had seven rooms. Little is known about its owner, Gustav Pisko, though he clearly had the courage to undertake an exhibition of the Neukunstgruppe, which was unlikely to be well received by the public. He covered himself by preparing a "Declaration of Obligations" for the group, which he asked all the exhibiting artists to sign: "The undersigned painters and sculptors undertake to send a sufficient number of exhibits (at least six pictures) to the exhibition to be held in December 1909 at the salon of Herr G. Pisko; and to cover any loss which may be suffered by Herr Pisko in the event that the exhibition cannot take place." At this time the Viennese had a cautious attitude toward modern art, and outside Munich or Berlin there were no magnanimous, successful art dealers to encourage the rising generation of artists in the hope of long-term, lucrative discoveries.

Munich art dealer Hans Goltz, who gave Schiele a one-year contract (1912–1913), sold a few of his prints but did not manage to make him well known in Germany. Admittedly Schiele, with his often excessive demands, did not make it easy for the gallery owner to look after his interests. The planned second exhibition at the Galerie Arnot in Vienna fell through because of the conditions imposed by Schiele, and provoked its owner to remark laconically: "The Galerie Arnot cannot survive simply from the honor conferred on it by Herr Egon Schiele in exhibiting his works there."

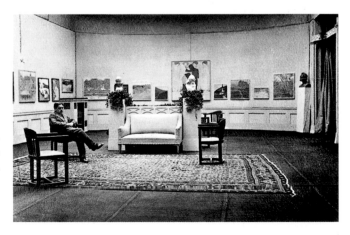

Portraits

If an artist was able to win over the wealthy upper-class clientele of Vienna, portrait painting could be a lucrative business, and it was not by chance that at the start of his career Schiele made efforts to draw attention to himself in these circles. With the Massmann and Peschka portraits (this page and opposite), in which the influence of Klimt and of the Secession are still plainly visible, he was attempting to take account of the taste of the time. Both paintings are structured in three parts: a decorative surface formed by the chair, an empty background, and the figure of the sitter. Clearly intended as showcase

Hans Massmann,
photograph

Massmann, a painter and etcher who had studied with Schiele at the Academy, was one of the founding members of the Neukunstgruppe.

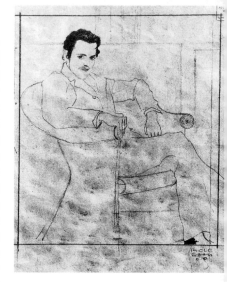

Portrait of the Painter Hans Massmann, 1909
Oil on canvas
120 x 110 cm
Private collection

In accordance with the taste of the time, Schiele chose an almost square format. The composition is essentially two-dimensional: space and body mass are created by contrasts of light and dark between the background, the chair, and the sitter's dark clothing and hair. Massmann's face is almost in profile. His distinguished appearance, and the elegant pair of gloves, establish his social status.

Study for the Portrait of Hans Massmann, 1909
Drawing
42.5 x 29.5 cm
Private collection

This study shows less compositional severity than the later oil painting. Massmann turns slightly toward the observer, his gaze direct and frank. The face is seen in three-quarter profile, which, in contrast with the painting, makes him appear less cold and unapproachable; in this study he is far less the aristocratic dandy shown in the final portrait. Both works were exhibited at the Kunstschau in 1909.

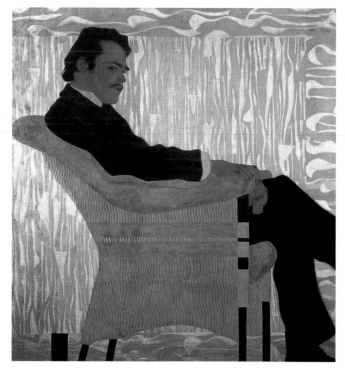

Portrait of the Painter Anton Peschka, 1909
Oil on canvas
110.2 x 100 cm
Private collection

The composition of this picture is very similar to that of the Massmann portrait (opposite). It is in fact almost a companion piece, with both subjects shown sitting in armchairs in front of decorative, almost abstract, backgrounds. In this portrait, however, we seem a little closer to the sitter. For both pictures Schiele created various decorative elements. The Massmann portrait is set against a background with a stylized pattern of wavy lines that seem to have a broad border; for the Peschka portrait Schiele created an irregular pattern consisting of subtle gradations. Peschka's gaunt, sinewy hands possess an early hint of that power of expression that Schiele was to give to the hands in later portraits. At this early point in Schiele's development, closeness to reality was still important to him, and he portrayed the heads of his subjects with great accuracy.

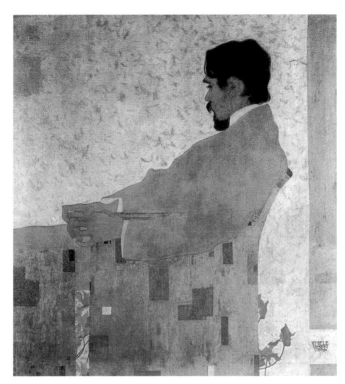

Anton Peschka, photograph ca. 1909

The painter Peschka was a member of the Neukunstgruppe and was linked to Schiele not only by friendship, but also by family ties - through his marriage to Gertrude (Gerti) Schiele in 1914, Peschka became Schiele's brother-in-law.

portraits, these two works were meant to open doors for him in the houses of affluent clients. Over the next year Schiele found his own style and worked very hard, producing 11 portraits in all. In these two portraits there are still decorative elements derived from the Jugendstil, but the unornamented background in front of which the figures are seated is quite new. In addition, the posture of the hands and bodies has become an important means of expression. Schiele was convinced that he had a future as a portrait painter, and indeed in 1910 he received a commission from one of the most outstanding architects of Vienna, Otto Wagner. Wagner also advised him to paint a series of portraits of well-known Viennese personalities: "This will attract attention to you; you will become well-known at a stroke, and receive important commissions as a result." This promising project came to an end almost immediately, for Wagner's portrait was never finished; Wagner, dissatisfied with the result, and losing interest as a result of the number of long sittings, withdrew his offer. During this brief period of intense creativity Schiele did not succeed in rising to the rank of portraitist to Viennese high society. His clients came only from the small circle of his friends and admirers.

Schiele's Sense of Line

Schiele drew rapidly; his pencil glided, as if guided by a spirit hand, over the surface of the white paper, in a manner which was sometimes like the brushstrokes of East Asian painters.

Otto Benesch, 1958

Undoubtedly Klimt was Schiele's model where drawing was concerned, but the work of the French artist Henri de Toulouse-Lautrec (1864–1901) also left its traces. For both Schiele and Toulouse-Lautrec a drawing was not used merely as a preparatory sketch for a painting, it was produced for its own sake, because of its own unique qualities. Drawing was for them an independent art medium; in particular, it was a medium that was free from the need, irresistible in oil painting, to finish a work, to make it complete. Much of the appeal of a drawing lay in what was only suggested and apparently incomplete. Klimt's line is nervous, never clean and strong, so that bodies appear to tremble, to vibrate, to breathe. Because of his preference for fluid contours, he usually used a soft pencil or chalk, and made sure that the form was closed. Schiele turned away from this style and developed a thin, precise line with his pencil, which delineates the figure with a hard, sharp outline. He translated soft, rounded areas of the body into angular ones, and in doing so often gave his figures an emaciated quality. Figures and objects are mostly drawn in clean outlines; only rarely is the inner form defined. There is no shading that might convey bones, muscles, or shadows. The faces usually have a portrait-like individuality, and the sexual characteristics are emphasized, with the genitals and the nipples being clearly outlined. Schiele made "omissions" in virtuoso fashion; in some places he did not draw the ends of lines, but left empty spaces, so that a "gap" appears that the observer must complete mentally. Thus the line acquires an intrinsic value that lends it an almost autonomous status in relation to the figure it encompasses. Its effect is that of a purely graphic element. Schiele loved to add color to drawings, but without allowing the color to compete with the line. He also liked to contrast the black line with adjacent white surfaces. For Schiele, the purpose of color was to heighten the expressive effect of line.

Portrait of a Lady (The Dancer Moa), 1912
Pencil on paper
48.2 x 31.9 cm
Vienna, Graphische Sammlung Albertina

Mime van Osen with Slouch Hat, 1910
Watercolor and black chalk
45 x 31 cm
Vienna, Sammlung Dichand

This portrait is of a founder member of the Neukunstgruppe, Erwin Osen (1891–1970), also known as Mime van Osen, who lived with Schiele in Krumau. The *Portrait of a Lady* (opposite) shows van Osen's lover, who accompanied him and Schiele to Krumau, and whose "exotic aura" inspired Schiele to create several drawings. The watercolor portrait drawing demonstrates an astonishing relationship between executed passages and the areas of the paper that have been left blank. Only the two thin lines that connect the head with the hands suggest the impression of a body, which the observer does not actually see but supplies mentally. Here Schiele employed the technique of simplification and suggestion in a very radical manner.

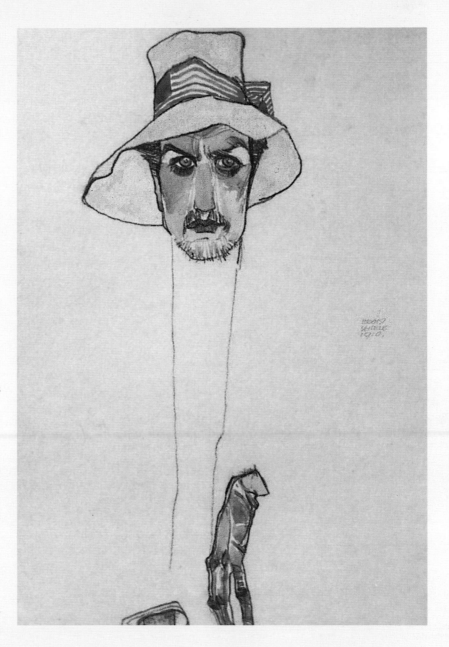

Friendships

Only rarely in the history of modern art has a young, unknown artist been able to acquire influential patrons who took his part when things went wrong, who bought his work regularly, and who supported him financially. Schiele was exceptionally fortunate in this respect. At the very beginning of his career he made the acquaintance of influential art critics and important collectors. Perhaps his most important encounter, made during 1909, was with the art dealer and writer Arthur Roessler. Through his contacts, Roessler was able to put Schiele in touch with many influential collectors. These wealthy men were all considerably older than Schiele, and the generation gap sometimes led to friction and irritation on their part. In some cases, however, the friendships became very close and several collectors supported him generously. Roessler maintained a strong relationship with Schiele that went beyond a shared interest in artistic matters, and in the summer of 1913 he invited the artist to his vacation house at the Traunsee. Heinrich Benesch, too, was a frequent companion of Schiele and his mistress, Wally, and met them regularly at coffee-houses. Little is known about Schiele's relationships with women at this time, apart from those with his sisters and with Wally.

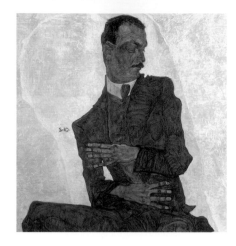

Portrait of Arthur Roessler, 1910
Oil on canvas
99.6 x 99.8 cm
Vienna, Historisches Museum der Stadt Wien

Roessler (1877–1955) was an art critic, writer, and gallery owner. He had traveled widely and in 1911 became art adviser to the newspaper *Arbeiter-Zeitung*. An enthusiastic collector of Schiele's work, and a selfless supporter of his art, Roessler made Schiele well known through essays, reviews, and books.

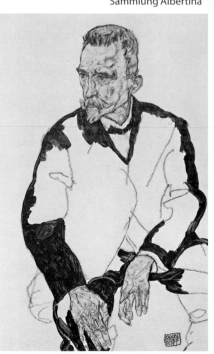

Below:
Portrait of Heinrich Benesch, 1917
Drawing
45.8 x 28.5 cm
Vienna, Graphische Sammlung Albertina

Heinrich Benesch (1862–1947) was central inspector on the Austro-Hungarian railroad. In spite of his limited income as an official he became the most important collector of Schiele's drawings, and also bought some of his paintings. Kindly and generous, he was a helpful friend and supporter of the artist. In his enthusiasm he wrote at the beginning of their friendship: "May I ask one more thing of you, dear Herr Schiele, please do not put any of your sketches, whatever they may be, even the smallest and most inconspicuous, into the stove. Please write the following equation on your stove in chalk: Stove = Benesch."

\nton Peschka,
photograph 1906

\nton Peschka
1885–1940), who
narried Schiele's
ister Gerti, was linked
o Schiele by a
felong friendship, as
nnumerable letters
rove. In 1912/13
eschka worked for
he stage painter
nton Brioschi, who
vas for many years in
harge of the décor of
he Vienna State
Opera productions. A
etter by Schiele from
is time in Krumau is
reserved, in which
e defends his friend's
elationship with
Serti, who was then
nderage: "She must
e with Peschka in a
oble way, for as far as
know she loves him,
nd that is not to be
eld against him. She
nd Peschka can

make excursions to
wherever they like, I
think this much of
Peschka; he knows
what a rogue he
would be if he were to
break off the plant
before it ripens, and
Gerti would be a vile
person in my eyes if
she suffered being
touched in that way."
Unlike Schiele,
Peschka volunteered
for military service in
1915, and was
severely wounded on
the Italian front. After
the war he took up his
career as an artist
again, but with little
success.

Above:
Johannes Fischer,
1918
Etching
38.3 x 32 cm
Vienna, Historisches
Museum der Stadt
Wien

The painter Johannes
Fischer (1880–1955)
took several
photographs of
Schiele. For a long
time he spent several
hours with him every
day. His photographs

provide fascinating
insights into Schiele's
studio and also,
because he often
struck various
expressive poses for
them, Schiele's
conception of himself.

Gustav Klimt,
photograph 1914

In order to
characterize the
relationship between
Klimt and Schiele, the
writer and art critic
Arthur Roessler
recorded a revealing
anecdote. When
Schiele asked the
admired master if he
might exchange
drawings with him,
Klimt is said to have
replied: "Why do
you want to
exchange drawings
with me? After all,
you draw much
better than I do."

Self-presentation and Self-portraits

It is striking how frequently Schiele portrayed himself – in fact he created about a hundred self-portraits. The self-portrait developed during the Renaissance, and since then the mirror has been the essential instrument for discovering one's own identity. Painters such as Albrecht Dürer, Rembrandt, and Vincent van Gogh are among the great masters of this genre. Up to the beginning of the 20th century, self-portraits were often statements about a life, or acts of self-definition. Schiele broke with this tradition: he was not recording his own social or emotional situation, but exploring the strange, the unknown, the so-called dark side of himself. With their eccentric poses and extreme gestures, his self-portraits create an alienated image, laden with tension. Here the mirror does not reflect self-assurance and self-confidence; another being stares out of it, a being whose features are distorted by grimaces or bizarre mimicry, whose body is unnaturally twisted and emaciated. From 1910 the nude self-portrait became a central theme for Schiele.

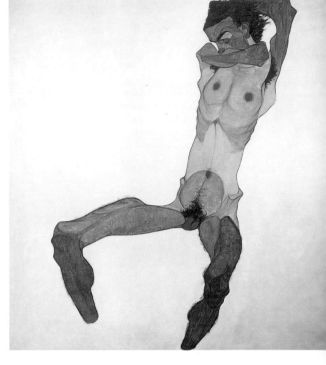

Self-Portrait, 1918
Sculpture, Historisches Museum der Stadt Wien

Seated Male Nude (Self-Portrait), 1910
Oil and gouache
152.5 x 150 cm
Vienna, private collection

The most common images of (almost) naked men in European art history were those of Adam, the crucified Jesus, and a few saints. This is significant for the understanding of Schiele's self-portrait, since he places himself in the tradition relating to images of Jesus Christ. This nude self-portrait, which is unique among representations of naked men at that period, is not realistically painted. The figure is elongated and without feet, and its emaciated musculature protrudes unnaturally, making the body appear dried up and knotted. Despite its shocking outward appearance, the figure seems to glow from within; eyes, navel, and nipples are a brilliant red.

Below:
Self-Portrait with Black Earthenware Pot, 1911
Oil on wood
27.5 x 34 cm
Vienna, Historisches Museum der Stadt Wien

Schiele's radical approach to composition is particularly evident in this self-portrait. The picture looks as if it had been cropped on three sides, so that the figure appears on the left, cramped and confined. The spatial situation remains undefined, and the isolated objects scattered around are not immediately self-explanatory. Schiele gazes questioningly at the observer, his eyes wide open and forehead wrinkled. The expression on his face is difficult to determine; his hand appears to be injured. The meaning of the outspread fingers (a gesture that appears often in his portraits) remains obscure; perhaps it refers to the gestures seen in medieval images of saints (pages 80–81). The black earthenware vessel is shaped like a man's head and, together with Schiele's head, forms a Janus-like double head; it may be an image of a second, darker self. The picture is painted in a technique closely related to varnishing, the colors being applied in thin layers so that they acquire an intense luminosity.

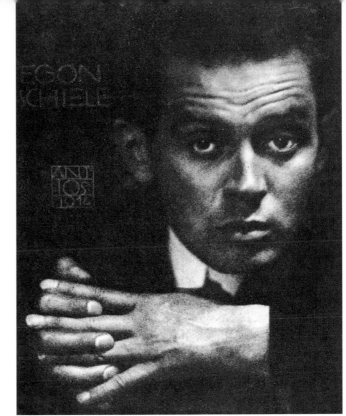

Above:
Egon Schiele with clasped hands, photograph 1912
Anton Trčka

The photographer Anton Trčka made several portraits of Schiele. As they are in no way inferior to the self-portrait drawings in their artistic effect, we can assume that he and Schiele exchanged ideas about the composition of the photographs. Schiele struck self-conscious poses for the camera lens just as he did for his self-portraits. In this example he gazes questioningly at the observer, frowning. The hands are exceptionally prominent in the picture and almost at right angles to the head. For Schiele, who discovered photography for himself in 1914, photographs were works of art in their own right.

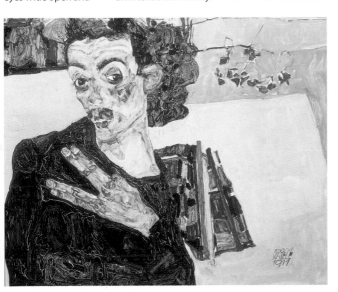

Schiele's Use of Color

In a certain sense this Schiele is a painting, threatening moralist; his visions of vice truly have nothing tempting, nothing seductive about them. He revels in the colors of decomposition.

Armin Friedmann in the *Wiener Abendpost*, March 21, 1918

Line versus color

Before he could develop his own style, Schiele first had to free himself from Klimt's concept of color. Schiele's early pictures are like a patchwork quilt of colored shapes, oblongs or triangles that come into being by means of a net of criss-cross lines. This often gives his paintings something of the look of enlarged colored drawings. In fact contemporary critics reproached him with the accusation that he was not a painter, but just a draftsman who no longer restricted himself to the small sheet of paper and simply transferred his technique to the more extensive canvas. Indeed, at first Schiele was not particularly interested in color in itself, which he always saw as secondary to line and form.

His *Woman in Mourning* (right), and, even more so, his *Portrait of Friederike Maria Beer* (opposite), with its clearly differentiated areas of color, both clearly show that he instinctively subordinated color to line; for Schiele it was line, not color, that determined form. Throughout his career he delineated his objects and figures with a clearly visible outline.

Composition and technique

The dark coloration and somber effect of many of his paintings between 1910 and 1915 – typically painted with brown, black, and green tones interspersed with small areas of bright colors – were not to the taste of his contemporaries: the unappealing pallor of the colors reminded them of death and decomposition. During the war years the colors on his palette became brighter, however, and he developed an enthusiasm for the various means of heightening the effect of colors. He experimented with painting techniques and methods: he tried unusual varnishes, for example, and in drawings and watercolors experimented with unfamiliar combinations of colors. He stirred rubber into watercolor paints and thus achieved a smeared, semi-opaque effect; he applied diluted watercolor paints to thin glossy paper, so that the paper became wavy and the paint formed bubbles and dried irregularly. The effect of such technical experiments met with little understanding on the part of the art-loving public.

In his *Woman in Mourning* everything except the face is reduced to surfaces that are clearly distinguished from each other. The paint is applied in much diluted form to the primed wooden surface, so that the color is irregular and the brushwork remains visible. In other small-format pictures of the same period Schiele reveals a fascination with brilliant colors and bright patterns. The *Portrait of Friederike*

Woman in Mourning, 1912
Oil on wood
42.5 x 34 cm
Vienna, private collection

Maria Beer, with its splendidly patterned dress, is one of the most striking examples of Schiele's interest in color and contrast.

Color as a means of expression

Only a few critics recognized that Schiele was using blotchy or dull colors in order to heighten the expressive power of his images. Varying the quality of the color and the texture of the painted surface was Schiele's way of distancing himself from Klimt's exquisitely worked surfaces and pure colors. Only in his later years did his concept of color begin to change, and in 1918 he had reached the point of giving color a value and significance of its own. This becomes clear in a portrait of his wife Edith (page 78), which he reworked during the last year of his life, and in a portrait of his friend Albert Paris Gütersloh. In these later portraits the areas of color possess an almost abstract quality; they are liberated from form. He was now no longer concentrating exclusively on the expressive quality of the line, but also on the physical quality of paint, and made use of this both in the description of form and volume, and also in the creation of mood.

Portrait of Friederike Maria Beer, 1914
Oil on canvas
190 x 120.5 cm
Private collection

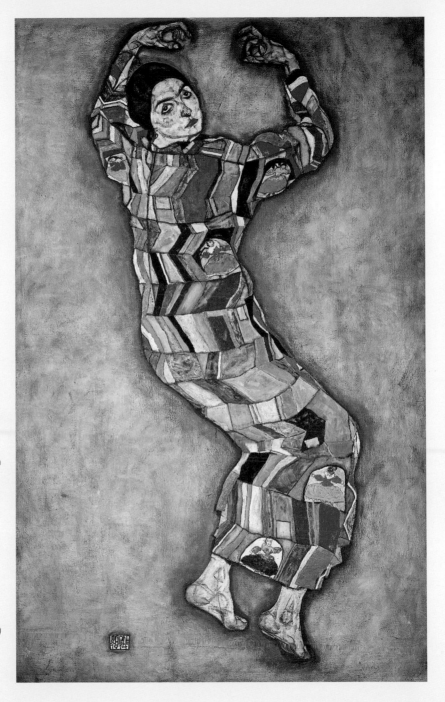

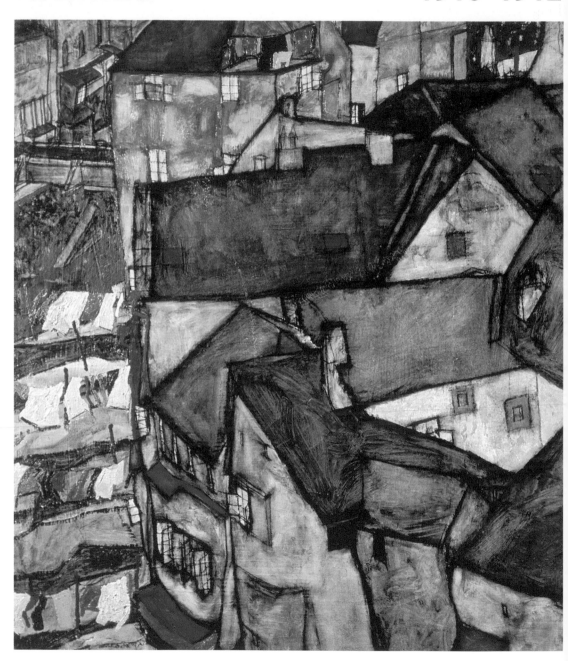

The next year and a half were characterized by long stays in the small town of Krumau in southern Bohemia. Schiele discovered new themes, such as townscapes and children, and turned once again to landscape. He also created a series of symbolic figure compositions in which, among other themes, he confronted death. Stimulated by the poems of the French writer Arthur Rimbaud (1854–1891), he began to write poetry himself, and from 1910 he also began to give his pictures "poetic" titles such as *Dead City*. His trips to Krumau were an escape from the city. He was bored with Vienna. The first of his portrait commissions hardly provided a secure income, since his modest fees arrived slowly and in installments. The serenity and calm he hoped to find in small-town life also contributed to his decision to live in the provinces. Reality soon caught up with him, however: in 1911, when he set up home in Krumau with his model, Wally Neuzil, the locals made life very difficult for the unmarried couple. Forced to leave, they settled in Neulengbach.

Emperor Franz Joseph

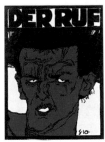

Self-portrait on the cover of *Der Ruf*, 1910

1910 Chemotherapy is developed for the treatment of infectious illnesses. At 80, Emperor Franz Joseph is the oldest monarch in Europe. Wassily Kandinsky paints his first abstract pictures.

1911 In Austria there is a vigorous nationality dispute. The first International Women's Day for equal rights is held. Van Gogh's *Sunflowers* is acquired by the Bayerische Staatsgemälde-sammlung (Bavarian State Collection of Paintings) in Munich.

1910 Schiele visits Krumau, one of his paintings is exhibited at the International Hunting Exhibition in Vienna, and he meets the collector Heinrich Benesch.

1911 Schiele holds his first exhibition at the Galerie Miethke, managed by Roessler, in Vienna. Schiele settles in Krumau with Wally Neuzil and sets up a studio there.

Opposite:
Houses in Krumau (detail), 1915
Oil on canvas
109.7 x 140 cm
Jerusalem, Israel Museum

Right:
Studies of Trees, ca. 1913–1918
Private collection

Old Gabled Houses in Krumau, 1917
Black chalk
45.8 x 28.8 cm
Vienna, Graphische Sammlung Albertina

Schiele created this famous drawing during one of his many trips to Krumau. With highly skilled economy, he here concentrates on the essential elements of the old houses. He uses only outline drawing and avoids all internal detail; his aim is not realism. The fascination of this drawing resides in its austere simplification of forms – for example, the reduction of the street signs to their bare outlines. As if we were just glancing at the building, our gaze moves rapidly from the lightly sketched lower story of the house upwards over the windows to the guttering and then to the gable, where it lingers. Despite this economy, the drawing creates a vivid impression of a narrow, winding lane in a corner of an old provincial town.

Below:
House Wall (Window), 1914
Oil and gouache on canvas
110 x 140 cm
Vienna, Österreichische Galerie

Schiele's eye for the apparently insignificant details of this house wall is what makes him so modern: it is a fragmented view. No longer able to comprehend the total sum of phenomena, the modern mind attempts to grasp the meaning of the world in a fragment.

Views of Krumau

Krumau, a small, self-contained town with Gothic, Renaissance, and Baroque buildings, was and still is a picturesque town. "If ever chance, a fancy for leisurely travel, or the death of your favorite rich aunt takes you to southern Bohemia, do not be deterred from spending a day in the charming little town of Krumau," recommended the poet Rainer Maria Rilke (1875–1926) in 1895. Schiele's mother was born in the town, and his father had spent some time there. Its small size and the access it provided to a richly varied countryside were in its favor. Yet, despite his interest in nature, Schiele painted not the romantic Bohemian woods, but views of the town (he once said that he had two passionate interests: people and urban scenes). But he took no pleasure in modern "stone deserts": he loved historical towns that had grown organically over the centuries and become part of their natural surroundings. Krumau was such a place, and it offered Schiele a set of aesthetic values that were in sharp contrast to those of Vienna. He now drew a series of town views in which he stressed the charm of crooked little streets, full of odd corners, though without slipping into a post-card-like sentimentality. Moreover, his views are far from being realistic depictions, for he improvised freely on the architecture and topography of the scenes, subordinating factual reality to his own distinctive and

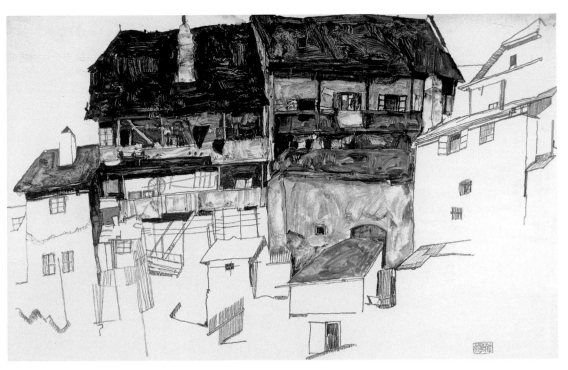

sometimes bleak vision. His urban views are fragmentary. "I make preliminary sketches, too, but I find, I know, that copying after nature is a meaningless exercise for me, because I paint pictures from memory better than views of landscapes." The results were urban visions whose streets and squares are quite deserted.

Old Houses in Krumau, 1914
Pencil and body color
32.5 x 48.5 cm
Vienna, Graphische Sammlung Albertina

This drawing proves that Schiele's visions of townscapes were sometimes preceded by precise studies. Here, for example, he made a careful drawing of a higgledy-piggledy arrangement of half-timbered houses in Krumau. The techniques used in this drawing illustrate how, in the course of the town's development, earlier buildings were gradually extended and renovated, given additional stories or entirely altered, without destroying the general impression of the old Bohemian town. While in the foreground Schiele suggests the architecture by means of outlines and light shading, in the background he provides a more detailed and substantial depiction of the buildings. As with a photograph, the background can be seen more clearly than the foreground. Here we see the everyday aspect of Krumau. The two-dimensional form of the foreground resembles the execution of Schiele's townscapes painted in oils. In the paintings, as in this drawing, the facades are reduced to flat surfaces with a few regularly distributed openings. The letters scattered over the sheet are indications of color, notes that helped Schiele to complete the drawing later or to prepare a painting from it.

The *Dead City* series

For Schiele, Krumau was also "the Dead City," a description which probably has biographical roots. As a child, Schiele remembered, he had entered "well-nigh endless towns, which appeared to be dead." It was in Krumau that his father, a few months before his actual death, had nearly hurled himself into the river Vetava.

This contemporary concept and motif of the "dead city" probably derives from the novel *Dead Bruges* by the Belgian Symbolist Georges Rodenbach (1855–1898), which may have been brought to Schiele's attention by his friend Arthur Roessler. Roessler had written an essay on the relationship between this novel and early Flemish painting. Otto Benesch, the art historian, also saw a connection between Schiele's *Dead Cities* and early Flemish art: "One must go very far back to find that quality which is dark, unreal, and yet also very real, as far back as the Flemish painters of the 15th century." How firmly the combination of death and civilization preoccupied Schiele's contemporaries can be gauged from the creation of many works of art, including two celebrated German poems, entitled *The Dead City*. Similarly, the painting *Deserted City* (1904) by Ferdinand Knopff, with its tinge of Surrealism, depicts a desolate Bruges.

In Schiele's *Dead Cities*, life appears to be suffocated by the cramped house-fronts and narrow

Above:
Postcard of Krumau, May 1911
Egon Schiele sent this postcard – "Greetings from Krumau" – to

Arthur Roessler on May 15, 1911. This detail shows the little medieval town below its tall Gothic castle tower.

Below:
Dead City III, 1911
Oil on wood
37.1 x 29.8 cm
Vienna, private collection

This painting illustrates Schiele's free treatment of topography. He allows the river Vetava to flow on two sides of the mill so as to isolate the buildings visually, and creates what is almost an anthropomorphic effect.

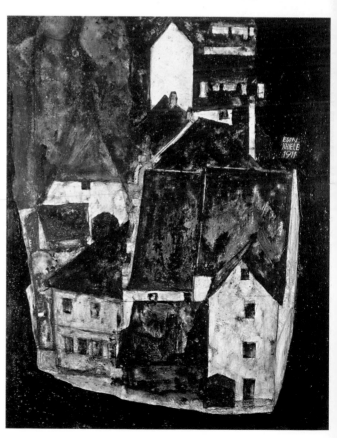

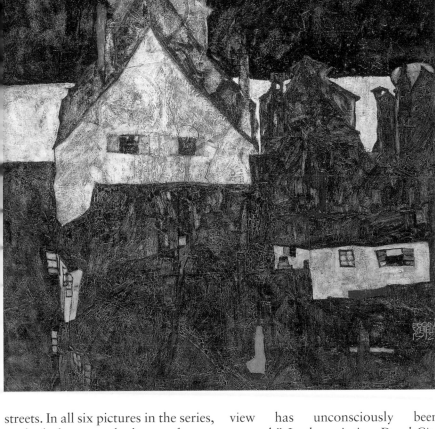

Dead City IV, 1912
Oil on wood
80 x 80 cm
Zurich, Kunsthaus

In this view the actual architectural details are ignored. The houses are crammed together so densely that there seems to be no space for passing between them. They form a dark mass with a mysterious inner life of its own. The perspective is illogical: the roofs and facades, seen from above, are not based on any traditional perspective view. In fact, the houses are perceived not as three-dimensional spaces but as surface. The impression of depth is created by placing buildings above each other, a principle commonly used in medieval painting before the discovery of vanishing-point perspective. There is little of the picturesque in this view of the old town. On the contrary, the walls have a forbidding look, the very dark colors creating a somber and unreal scene.

streets. In all six pictures in the series, we look down on the houses from a high viewpoint. Perhaps the notion of a "dead city" acted as a mirror to Schiele's psyche, reflecting his grief over the loss of his father. His friend, the artist Albert Paris Gütersloh (1887–1973), wrote about these town views: "A town which appears foreshortened to him because he sees it from above, he calls the dead town, because every town is a dead town when seen in this way. Here the cryptic meaning of the bird's-eye view has unconsciously been guessed." In the painting *Dead City IV* (above) the jumbled areas of color have an almost abstract quality. Even more, through his crude contrasts of light and dark Schiele achieves an almost sinister effect. The ungainly house emerges from its dark background like a primitive mask. The town-views of Schiele's last years were still portrayed from a bird's-eye view, but were brighter in color and more cheerful in mood.

Portraits of Children and Nude Studies

Depictions of children form an important part of Schiele's output. This theme, however, is not found in his work alone. The painter Oskar Kokoschka (1886–1980) also made drawings of children, often those he liked to seek out in the streets of slum areas. Schiele did the same, finding his young models in the working-class districts of Vienna. Children were also said to have frequented Schiele's studios in Krumau and Neulengbach. His interest was above all in young girls, whom he preferred to depict half-dressed or naked. His young nude models are mostly on the brink of puberty, and in their gaze one can read both the confusion of adolescence and the alert awakening of sexuality. But in his unequivocally erotic drawings Schiele goes even further. Here he shows the scrawny, undeveloped bodies of young girls, and some of them are uncompromisingly frank; one drawing is of a young girl masturbating. There was a market for such officially outlawed drawings precisely because masturbation was harshly repressed as an illness and a moral scourge that had to be fought by the most drastic means. But it is clear from the manner in which he depicted his young nude girls that Schiele was not concerned here only with the lucrative production of pornography. In these works, skinny, unhealthy-looking teenagers, often gazing directly at the viewer,

seem to be trying to assert their own individuality.

In the meantime Schiele was also producing portraits of children like that of the young Herbert Rainer (opposite above). This is among Schiele's most realistic portraits of a child, presumably because it was a commissioned work.

Nude on Colored Fabric, 1911
Pencil and body color on paper
48 x 31 cm
Vienna, private collection

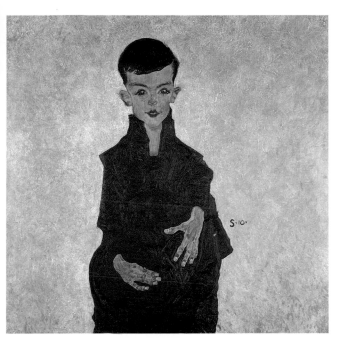

The Rainer Boy (Herbert Rainer), 1910
Oil on canvas
100.3 x 99.8 cm
Vienna, Österreichische Galerie

As in other portraits he painted in 1910, here Schiele places a subject seen in three-quarters length in front of an empty background. Here too the hands, whose pale skin sets them in stark contrast to the dark clothing, are an important means of expression. In fact the position of the hands is anatomically impossible: Schiele was always happy to sacrifice literal accuracy for expressiveness. However, the boy's gesture is much less mannered than in the other portraits of this period and Schiele has refrained from distorting the face in order to heighten the expression – this restraint may be explained by the fact that this was a commissioned portrait. The figure is slightly off-center to the left, which gives the artist's signature, carefully set on the right of the picture, an additional compositional function.

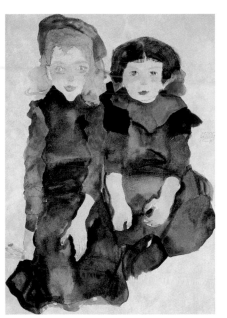

Left:
Two Little Girls, 1911
Pencil and watercolor on paper
41 x 32 cm
Vienna, Graphische Sammlung Albertina

Here the complementary colors red and blue cause the figures to stand out strongly. Watercolor paint fills the areas previously drawn in pencil.

Right:
Two Girls, 1911
Pencil and body color on paper
51.3 x 37.7 cm
Vienna, private collection

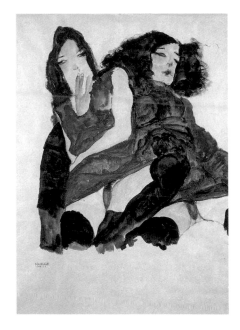

Landscapes as Pictures of the Soul

Throughout his career Schiele produced pictures of nature, above all images of flowers and landscapes. In early examples, the natural object is placed at the front of the composition, as for example in *Autumnal Tree with Fuchsias* (bottom right) and *Autumnal Tree in the Wind* (top right). In most of his landscapes, naturalistic space plays a subordinate role; the ground is mostly suggested by a horizontal strip and the sky becomes an empty, almost monochrome surface. It was only after 1916 that he treated space three-dimensionally.

All Schiele's landscapes are concerned with mood. Very often they are the symbolic expression of the basic realities of human existence, notably decay and death. After his brief "Impressionist phase," Schiele had no interest in capturing the ever-changing light and color of a landscape; nor in creating a landscape that symbolized "nature untouched by civilization," an approach developing among the German Expressionists of the period. For Schiele, nature was a "living, breathing space," in which "life itself" burgeons and then withers.

It is no accident that Schiele's favorite seasons were autumn and winter, for stark, leafless trees impart a melancholy and gloomy mood to their surroundings. In his flower studies, similarly, he was moved by

Left:
Schiele behind his picture *Autumnal Tree in the Wind*, (1912), photograph ca. 1912
Vienna, Historisches Museum der Stadt Wien

Below:
Autumnal Tree with Fuchsias, 1909
Oil on canvas
88.5 x 88.5 cm
Darmstadt, Hessisches Museum

Schiele's early flower and tree pictures made use of Klimt's principle of the decorative arrangement of natural objects.

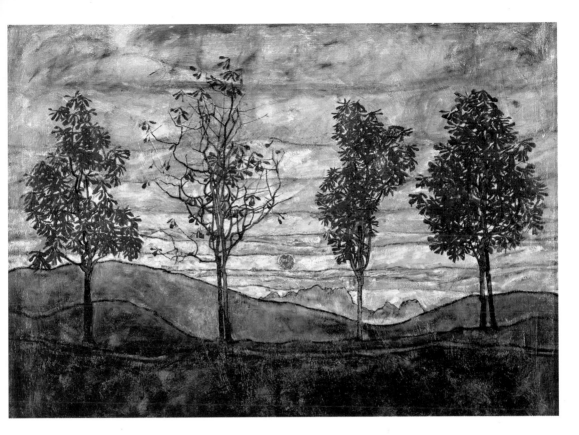

the fading of the flowers' former glory, while the brilliant colors of plants in full blossom hardly affected him at all. Decline and decay in the realm of both plants and people was his main theme. He once declared: "Most intensely, and with one's heart and being, does one experience an autumnal tree in the summer; it is this melancholy that I would like to paint."

Four Trees, 1917
Oil on canvas
110 x 140.5 cm
Vienna,
Österreichische
Galerie

The order and calm of nature – the row of trees and the strict composition – is the striking (and untypical) feature of this Schiele picture. The hilly foreground and the sky overcast with clouds form horizontal lines; the four trees divide the space vertically. But none of the trees extends to the edge of the picture or is cut off by it, as is the case with the artist's other tree pictures. Schiele used muted tones: his aim here was to capture the impression of a gentle summer evening. The fact that one tree has lost its red leaves is meant to suggest the transience of nature. The image here owes a debt to German Romanticism, which was an important reference for him. The intense back-lighting and the parallel layered zones of the picture are stylistic methods that were often used by Romantic painters.

The Influence of Vincent van Gogh

The importance of the Dutch painter

Schiele came across the works of Vincent van Gogh for the first time at the Kunstschau exhibition of 1909. Eleven paintings by the Dutchman were on display there, including his famous *Bedroom in Arles* (below). After the collector Carl Reininghaus had acquired this work, Schiele was able to study it in detail at his house. But in fact two years were to pass before Schiele directly confronted van Gogh's art and, under its influence, developed new subjects, such as interiors. While van Gogh found deep

significance in the depiction of rooms and everyday objects, these had no importance for Schiele until 1911: defining himself as a painter of figures, he felt that he was called to higher things. This attitude did not change until he moved to Krumau, for his experiences there convinced him that there was a parallel between his own life and Vincent van Gogh's, who had also left the city to retire to the country. At the beginning of September 1911, after renting a house at Neulengbach, Schiele painted his own room (*My Room*, opposite). The large-

format sunflower picture of 1911 (opposite) is also attributable to the fact that in the same year in which van Gogh painted his *Bedroom in Arles*, 1888, he also painted one of his famous paintings of sunflowers. Schiele now adopted the Dutchman's radically subjective view of inanimate objects, becoming convinced that objects and interiors could also express an artist's approach to life, for they too could reflect his or her relationship with the world.

Vincent van Gogh
Bedroom in Arles, 1888
Oil on canvas
72 x 90 cm
Paris, Musée d'Orsay

In 1888, in search of the clear light of the south, Vincent van Gogh left Paris for Arles in southern France and rented four rooms in what he called the "yellow house." One of his first subjects was his sparsely furnished bedroom, with its narrow bed, a small table, and two straw chairs. The brilliant effect created by the objects is achieved by the use of complementary colors. The presence of a single source of light is abandoned: there is a window, but no light comes from it. It is not through contrasts of light and dark or by means of shadow that the room and furniture acquire their volume, but by means of outlines that form the emphatic boundaries to the areas of color. Most striking of all is the unusual perspective, which diverges from the rules of conventional perspective construction. This heightened effect of depth draws the observer's gaze deeply into the picture. With his exaggerated colors and distorted space, van Gogh's picture gives visual expression to the intensity of his solitude.

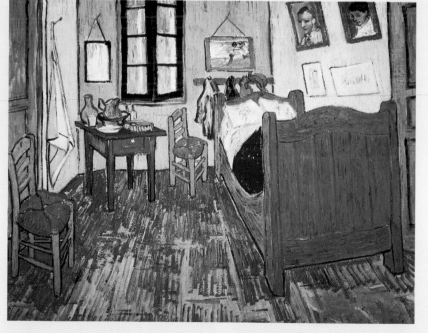

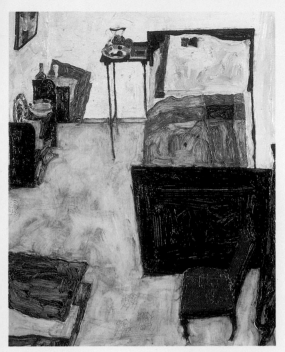

Below:
Sunflowers, 1911
Oil on canvas
90.4 x 80.5 cm
Vienna, Österreichische
Galerie

It was in Provence in southern France that van Gogh first experienced the glory of broad fields of sunflowers. Bright expanses of yellow stretched as far as the horizon below the azure sky. For van Gogh the sunflower was a symbol of nature and light, of life itself. Schiele's approach to nature was very different; he knew sunflowers only from the garden at home. As early as 1909 he had painted a single sunflower in an extremely tall format, a flower that has turned brown and whose dry, hanging leaves are vaguely reminiscent of human gestures. The single gaunt flower, painted in somber colors, becomes an image of sad and meditative feelings. The sunflower picture of 1911 (below) is similar in mood. Here the voice of transience predominates. The individual yellow flowers, which almost disappear in the profusion of great brown leaves, are in a final moment of defiance before their irrevocable decay. Schiele's wilting sunflowers conjure up the image of death. They are, as the German poet Georg Trakl (1887–1914) wrote, "flowers of melancholy."

My Room, 1911
Oil on wood
40 x 31.6 cm
Vienna, Historisches
Museum der Stadt Wien

This picture is among the *Brettl* or "little boards" among Schiele's work, a group of small-format oil paintings executed on wooden boards. The *Brettl*, which are similar to oil sketches in their manner of execution, were painted in one session. Of a convenient size, they were intended as personal mementos for collector friends. The correspondences between Schiele's and van Gogh's interiors are obvious. But the differences are important. The items of furniture are different: Schiele's bedroom contains simple but elegant pieces of furniture, quite in the taste of the Secession style. Schiele's work, moreover, lacks the same sense of depth. The corners of the room are vague and the floor is a single, unified expanse of color. The observer's viewpoint is indefinite; we look down into the room, which seems to have no entrance. The impression created by *My Room* is one of isolation.

Schiele and his Models

Schiele's preferred models were usually women with whom he had an intimate relationship. In his youth and his early years as an artist, it was his sister Gerti who above all took on this role, and until 1910 it was she who sat for his studies of pubescent girls. It is remarkable that his younger sister, apparently without embarrassment, allowed him to paint her in the nude. In view of the strict moral code of the time, this conduct appears positively enlightened and modern, but it is probably best explained by the highly unconventional character of the Schiele family.

His next model, Wally Neuzil (1894–1917), who was only a few months older than Gerti, modeled for Schiele from the age of 17. When she and Schiele fell in love, they moved to Krumau to live together, though there, being unmarried, they had to face the stern disapproval of the locals. Wally modeled for a range of erotic drawings and several symbolic figure paintings.

Finally, Schiele's third important model, from 1914, was his wife Edith. She made it a condition of their marriage that Egon should end his relationship with Wally and that she, Edith, should be his only model. Soon, however, she allowed him to use professional models again.

Gertrude Schiele, photograph ca. 1911

Below:
Seated Nude with Extended Right Arm, 1910
Black chalk and watercolor
45 x 31.5 cm
Vienna, Historisches Museum der Stadt Wien

Schiele's female nudes bear witness to his almost obsessive interest in women. In the early years of his career he showed a marked and sometimes disturbing preference for adolescent girls. This, however, applies only partially to this *Seated Nude*, since when this drawing was made his sister Gerti was 16 years old and her body fully developed. The emphasis here is less on the erotic than on formal qualities, principally the shape made by the model's pose. This watercolor drawing was a study for a painting that was shown at the International Hunting Exhibition and has since disappeared. It was once in the possession of the architect Otto Wagner and in 1910 was acquired by the architect Josef Hoffmann in a coffee-house, as a short note on the reverse indicated.

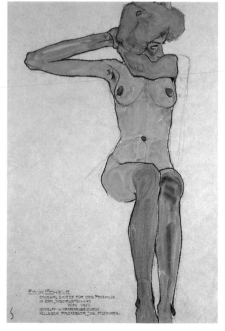

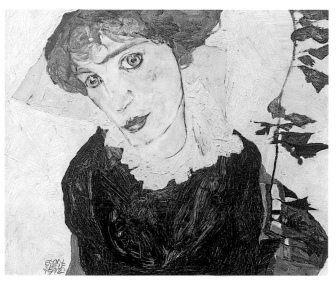

Below:
Edith Schiele, 1915
Drawing
44.5 x 40.5 cm
Vienna, Graphische
Sammlung Albertina

This drawing of Schiele's wife resembles the *Portrait of Wally* (left) in the posture of the head, but is more natural and relaxed. The sitter's facial features are not exaggerated and she occupies the more spacious composition of a conventional half-length portrait.

Edith Schiele with her dog in Schiele's studio, photograph 1917

Wally Neuzil,
photograph 1913
Arthur Roessler

Above:
Portrait of Wally,
1912
Oil on wood
32.7 x 39.8 cm
Vienna, private collection

This intense portrait of Wally, Schiele's model and lover, is the counterpart of a self-portrait by Schiele. She seems hemmed in by the frame, her face coming forwards towards the viewer. The large almond-shaped doll's eyes are also found in drawings of Wally Neuzil, who was the daughter of one of Schiele's teachers. In 1915, after parting from Schiele, she volunteered for military service as a Red Cross nurse, and in December 1917 she died of scarlet fever at Split.

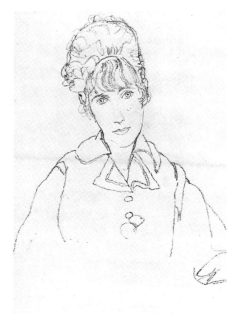

Erotic Art

The obscene

Erotic works of art form an important, indeed a central, group among Schiele's works. They are mostly watercolors and gouaches in which he goes far beyond the traditional nude, sometimes depicting the male and female genitals or sexual activity in an unequivocal and totally uninhibited way. For example, in *Woman Seen Dreaming* (1911) he shows a woman lying naked, her stockinged legs spread wide apart, pulling apart and displaying her large, vividly orange labia. Such depictions of foreplay and masturbation are part of a long tradition in erotic art. It is also evident that Schiele's preoccupation with erotic motifs was linked with commercial interests. Erotic works were bought and sold on a non-official art market and sometimes commissioned directly from an artist. It was unthinkable that they should be exhibited, as they were considered obscene and contrary to common decency. It was also illegal to do so: after a lawsuit against Schiele in 1912, he was sentenced to a brief term of imprisonment for "exhibiting erotic art to the general public."

Sexual taboos

Schiele's self-portrait as a masturbator is another example of his lack of inhibition: in *Eros* (right) his theme is his own sexuality. In contrast with his depictions of female masturbation, here he was exploring his own emotional and sexual life in front of the mirror. He was dealing frankly with a sexual practice that in his day was forbidden, and performed only in secrecy. At the same time he was freeing himself from a male ("pornographic") tradition that depicted almost exclusively the unshaven female genitals and masturbating women. The provocative nature of Schiele's *Eros* becomes far more intelligible against the background of the medical, psychological, and legal persecution of masturbation that continued well into the 20th century. It was an absolute taboo. At the turn of the century there was a positive "masturbation phobia," since it was believed that self-gratification was harmful to both mental and physical health. Doctors subjected patients to an often brutal physical mutilation. It was only Freud's pioneering studies into sexuality that gradually allowed a more tolerant attitude to develop.

The erotic work of art is also holy!

Egon Schiele

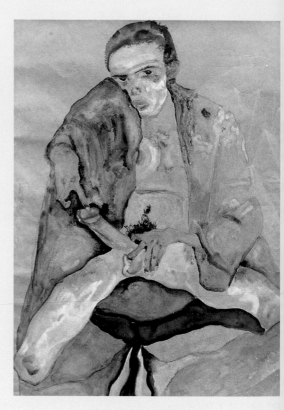

Eros, 1911
Gouache, watercolor, and
black chalk
55.9 x 45.7 cm
Private collection

The erotic nude

What is a nude? What makes it erotic? The British art critic John Berger gives an intriguing answer. He argues that the nude refers only to *experienced* sexuality; to be naked, by contrast, means to be oneself. As a nude, one is seen naked by others and yet not recognized as oneself; a naked body must be seen as an object in order to become a nude. Nakedness exposes itself; a nude is exposed by others. If a person is exhibited naked, his or her nakedness becomes a particular kind of disguise. For this reason the nude is, in effect, a form of clothing. Schiele's nudes show the naked body as an object; in this they are still firmly in the tradition of this art form. What is new is his assertive display of sexuality. In the official nude art of the 19th century it was unthinkable to show pubic hair and the vulva; in early erotic photography the primary sexual characteristics were brushed out, or the model wore an all-over skin-colored body stocking, which was made to imitate the appearance of classical statues. These nudes excited the sexual imagination of the observer without admitting an individual (active) sexuality on the part of the model. Schiele turned away radically from this approach, making the body that was capable of sexuality into the object of his art. He arranged his models in all possible (and some impossible) contorted positions in order to concentrate the gaze on an erotic focus.

The conventional nude in the salon painting of the 19th century is erotic only to a limited extent. It clothes itself in a modest nakedness. Schiele went beyond this convention. His nudes are "immodest" because they graphically show pubic hair and genitals, and depict sexuality unashamedly.

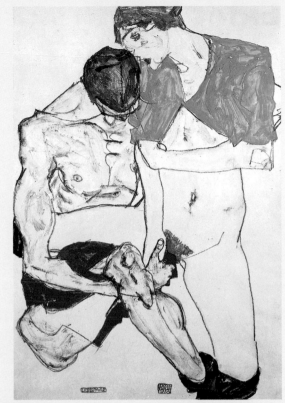

Right:
Lovers, 1913
Gouache and pencil on paper
48.5 x 32 cm
Private collection

Below:
Female Nude, 1910
Gouache and pencil on paper
31.6 x 44.9 cm
Private collection

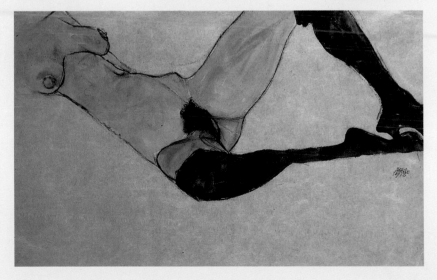

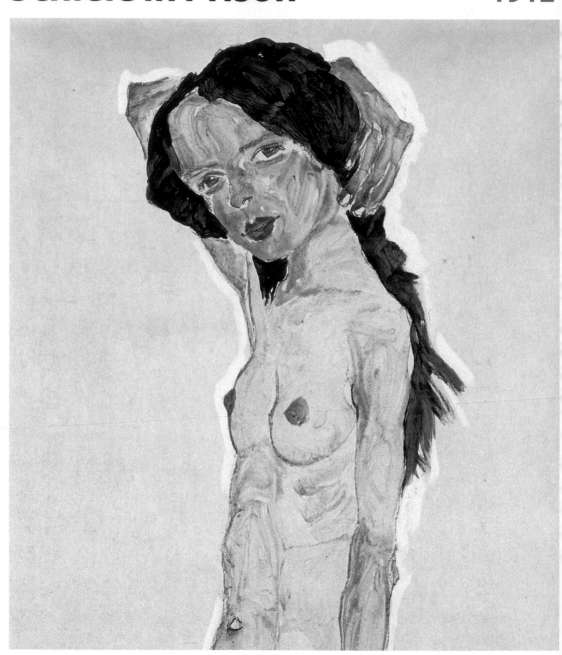

In 1912 Schiele was arrested and charged with the abduction of a minor and with indecency. The days behind bars were a shocking experience for him, and the affair threatened to have serious consequences: in the event of conviction, Schiele could expect a long term in prison. This incident, known as the Neulengbach affair, has been much discussed and analyzed, and has acquired a significance that is quite out of proportion. Schiele himself used the experience in order to characterize himself as the "victim" of an obtuse and hostile society. Coming after his experiences in Krumau, where his relationship with Wally had earned them public disapproval, he now felt his status as a condemned outsider confirmed. Schiele compared his fate to that of Vincent van Gogh, who was widely seen as the classic example of the unrecognized genius. It was now that Schiele began to identify with the Dutch artist and study his work intensively.

The Titanic in 1912

Egon Schiele
ca. 1912

1912 The Titanic sinks with a loss of 1,500 lives. The first German airmail service between Frankfurt am Main and Worms is established. The first version of the opera *Ariadne auf Naxos* by Richard Strauss is first performed, in Stuttgart. The art movement Futurism emerges in Italy.

1912 The Neukunstgruppe hold an exhibition in Budapest. The Galerie Goltz in Munich shows Schiele's pictures, together with works by members of the Expressionist group Der Blaue Reiter (The Blue Rider).

April 13 Schiele is arrested in Neulengbach and later transferred to St. Pölten.

May 8 Schiele is released from prison.

July Schiele takes part in an exhibition in the Hagenbund. He meets the innkeeper and art collector Franz Hauer. Schiele shows three works in the Sonderbund exhibition in Cologne. In the new year he is the guest of the industrialist August Lederer in Györ (Raab).

Opposite:
Black-Haired Nude Girl
(detail), 1911
Watercolor and
pencil with white
highlights
54.3 x 30.7 cm
Vienna, Graphische
Sammlung Albertina

Right:
Prison in Neulengbach,
photograph ca. 1963
Alessandra Comini

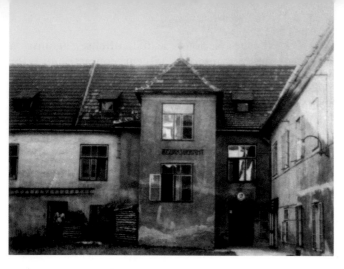

Prisoner, 1912
Watercolor and pencil on paper
48.2 x 31.7 cm
Vienna, Graphische Sammlung Albertina

This self-portrait was drawn when Schiele was in prison. He depicts himself in a wretched state; hollow-cheeked and bearded, his head to one side, he stares at the observer with great sad eyes. He looks more like the inmate of a concentration camp in his death throes than someone in custody. Schiele had no mirror in his cell, so painted his own portrait from memory. From a letter written by an official of the district court, reacting to the publication in 1922 to a newspaper review of the book *Egon Schiele in Prison*, we know that Schiele's prison conditions were in fact quite good. It is clear, for example, that he was allowed to paint, and he did not lodge any complaint about his treatment or conditions with the court at any stage of his detention.

Trial and Sentence

District courthouse and prison at Neulengbach, photograph

The file on Schiele's trial has not been preserved. In 1945 the Soviet army occupied the military court building at St. Pölten and the files kept there were burnt. Strangely, none of Schiele's friends had taken the trouble to ensure that the documents were copied for posterity. In 1922, a book called *Egon Schiele in Prison* was published, purporting to give a first-hand account of Schiele's time in prison, though it had in fact been written by his friend Roessler.

The good citizens of Neulengbach were predominantly Catholic country folk, and there were among them many who were concerned to maintain high moral standards. It is therefore not surprising that the "immoral relationship" between Schiele and Wally Neuzil met with as much disapproval here as it had in Krumau. The "foreign" painter's habit of allowing children to go in and out of his house was also noted with displeasure and deep suspicion. Heinrich Benesch later reported in his memoirs that he had repeatedly warned Schiele to be careful in his dealings with his child models and to do nothing without the parents' agreement. Schiele had always played down the danger. It was, then, the lax moral situation in the artist's household that induced the citizens of Neulengbach to intervene and so put Schiele in the dock: he was reported to the police for a

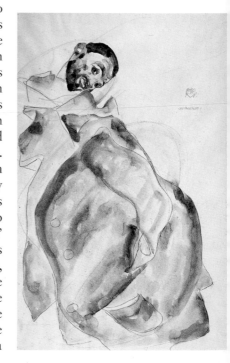

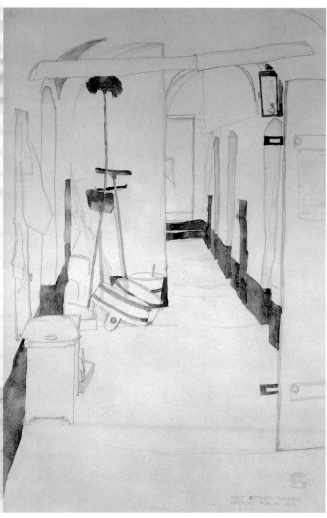

I Do Not Feel Punished, But Cleansed, 1912
Watercolor and pencil on paper
48.4 x 31.6 cm
Vienna, Graphische Sammlung Albertina

Schiele noted brief sentences on sheets of paper, an oblique way of commenting on and defending his behavior and his art. In the title of this drawing he interprets his prison sentence as a process of catharsis. A "martyr," which was what he believed himself to be, could not be punished. The drawing shows the corridor leading to the cells. The depth created by the perspective is strengthened by the spare use of watercolor and gouache, the result being a contrast between stark outline and painted details.

serious sexual offense against a minor (indecent contact), and for abduction. An official took offense at an erotic drawing that was hanging on the wall, clearly visible to children. Erotic art was legally prohibited from being shown in public. The drawing was confiscated and later burnt by the judge in the course of the trial. 125 further drawings were confiscated, but were later returned to Schiele. The charge of abduction was soon cleared up, because the child in question was a girl from Vienna who had followed the painter to Neulengbach of her own free will. Schiele was instructed to inform the girl's father, who then arrived to take her home. The charge of indecent contact came to trial, however, and Schiele's friends were so worried that they considered basing his defense on the plea of diminished responsibility. But the plaintiffs, the girl and her parents, changed their testimony in favor of the defendant. Schiele got off lightly with a sentence of three days in prison, and since the time spent in detention while awaiting trial was counted as part of the sentence, he was freed immediately. While in prison he produced 13 watercolor drawings that clearly reveal his strain and anxiety: a conviction for sexual relations with minors could result in a sentence of 5 to 20 years' imprisonment.

The Nude

The depiction of the unclothed human body takes a central place in Schiele's work; he pursued no other theme with the same passion and intensity. It has been said that Schiele matured too early and that during his puberty he became the victim of an inescapable inner turmoil and anxiety that was to torment him throughout his life, even in his relationship with Wally Neuzil and in his marriage to Edith Harms. His nude drawings and paintings certainly suggest as much. There is no denying that from an early age Schiele was fascinated by the naked, particularly female, body.

In the art of the late 19th century, particularly in academic salon painting, no subject was so frequently seen as the female nude. Schiele's great mentor, Klimt, produced countless nudes; his work would be greatly diminished without them. What is new in Schiele's approach to this

Crouching Male Nude, 1918
Chalk on paper
30.1 x 47.1 cm
Vienna, Graphische Sammlung Albertina

The motif of the outstretched arm, bent at a right angle, is frequently found in Schiele's work. The squatting attitude, which allows the gaze to fall upon the male genitals, was very unusual for a male nude at that time. By showing his own naked body in his images of unclothed males, and by enabling an unprecedented view of the individual shown, Schiele was breaking with the traditional principles of the male nude. Compare *The Family* on page 83.

Drawing a Nude Model in Front of the Mirror, 1918
Pencil on paper
55.2 x 35.3 cm
Vienna, Graphische Sammlung Albertina

The compositional arrangement of this drawing is as simple as it is surprising. Schiele shows himself in front of a mirror drawing a female nude, while the mirror and the room are invisible. He allows the observer to see the woman, clad only in stockings, from behind and also, as a mirror reflection, from the front. The sense of space is made comprehensible through the relative sizes of the overlapping figures. Our gaze is directed through the composition to the artist, who is studying his model with great concentration and objectivity. The woman takes up a self-assured pose in front of him. The relationship between the sexes shown here is a traditional one: the artist (male) is the subject and the creative force, while the model (female) is the object and source of inspiration. As a self-depiction of Schiele at work the drawing is unique.

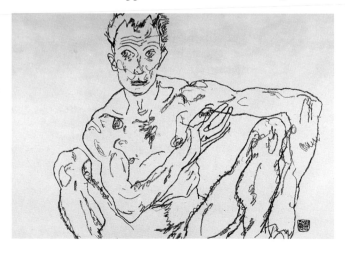

subject is his tendency to make the body appear ugly or tormented. Schiele's theme was less the *femme fatale* (the woman who was erotically attractive and dangerous to men) than the torment of the sexual drive and the speed with which the flesh withered. In his pictures he concentrated entirely on the body itself and dispensed with all ornamentation. For this reason he preferred to place his nudes in front of a plain, flat background. In later years he created works in which his models contort their figures in extreme ways in order to provide a view of the genitals. Schiele's voyeurism creates an impression of incessant and obsessive lust, and has encouraged the view that his sexual appetite was unhealthily overdeveloped. But the posture of his models is often stiff, their features expressionless. They have something agonized about them; they often seem anguished rather than lustful. The image of Schiele as an "erotomaniac" only becomes plausible, if at all, when we consider his nude self-portraits. These go beyond traditional attempts to depict the self, and should perhaps be seen as experiments in style and representation, or as the expression of his evident need to see himself playing various assumed roles. Particularly unusual are the nude self-portraits in which he shows himself masturbating. In view of the widespread taboo against self-gratification, no other contemporary painter displayed himself in such a sensational context.

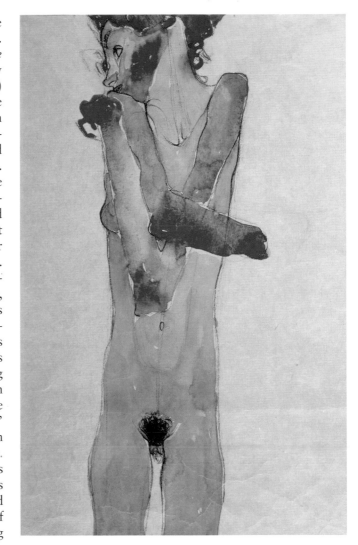

Nude Girl with Arms Crossed Over Her Breasts, 1910
Pencil and watercolor on paper
54.4 x 30.7 cm
Vienna, Graphische Sammlung Albertina

In this picture, for which his sister Gerti was the model, Schiele's treatment of color is particularly arresting. The body has green, red, and yellow patches, which underline its unhealthy-looking thinness. The subject's averted face and arms crossed over her breasts suggest a resistance to the viewer's gaze that is in marked contrast to the impression of vulnerability and intimacy created by the graphically emphasized genitals.

Schiele and Money

Schiele constantly complained about financial problems, and when he had money he quickly spent it, as an anecdote of Heinrich Benesch's illustrates: "I was sitting with Schiele and his model (and sweetheart) Wally Neuzil in the coffee-house in Hietzing. While Schiele played billiards, Wally told me that Egon was completely broke and had no idea how he was going to pay for his lunch next day. I was a bit short myself, but when Schiele had finished his game I gave him 10 Kronen for his immediate needs. What does our Egon do now? After we had separated, he goes to the Burgtheater with Wally, and after the performance goes to a restaurant with her and has just enough to

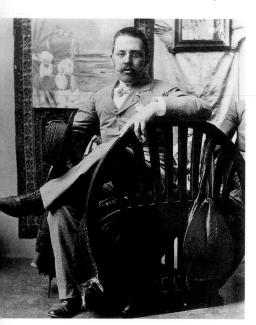

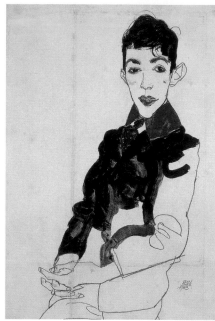

Portrait of Erich Lederer, 1913
Pencil and watercolor on paper
48.1 x 32.1 cm
Vienna, Graphische Sammlung Albertina

At the end of 1912 Schiele's financial position improved through a commission for a portrait from the Lederer family, leading industrialists who owned a distillery in Hungary. It was probably Klimt who recommended him to the Lederers, who were themselves among Klimt's most important patrons. For Christmas 1912 Schiele was invited to Györ in Hungary to paint the portrait of the son of the family, Erich Lederer. He befriended Erich and, apart from a large fee, also received a generous offer: whenever he was in financial difficulties he should send Erich drawings, which he would buy. Schiele made such extensive use of this offer that the Lederer family eventually owned 360 of his drawings. The luxurious conditions at Györ were very much to Schiele's taste, and he wrote to his mother that the people were extremely elegant and very pleasant.

Left:
Josef Hoffmann, photograph ca. 1900
Vienna, Historisches Museum der Stadt

The architect Josef Hoffmann had founded the Wiener Werkstätte (Vienna Workshop) in 1903 with the craftsman and painter Koloman Moser and the industrialist and banker Fritz Waerndorfer. In his role as its director, Hoffmann was always on the lookout for new talent, and soon became aware of Schiele. Once contact had been established, Schiele often asked the architect for letters of recommendation. It was probably also Hoffmann who helped Schiele exhibit at the Kunstsalon in Vienna and arranged for Schiele's sister Gerti to model clothes produced by the Werkstätte. Every circle of artists in Vienna had its *Stammtisch* or special table in a particular coffee-house, and Hoffmann, whose task was to bring artists and patrons together, took up residence in the Café Kremser, which he had himself decorated in black and white marble.

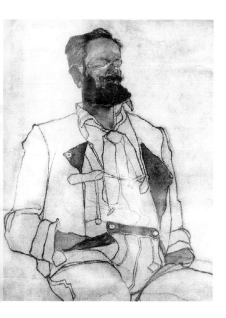

Portrait of a Gentleman (Carl Reininghaus), 1910
Gouache and pencil on paper
44.1 x 31.4 cm
Private collection

Carl Reininghaus owned a paint factory in Gösting, near Graz, and was the most important collector of modern art in Austria. He owned works by Manet, Cézanne, Renoir, Munch, and others. It was probably Reininghaus who paid Schiele's legal fees at the time of his trial. Apart from drawings by Schiele, he also bought the artist's entry for the Carl Reininghaus Prize for 1911, the oil painting *Encounter*.

Right:
Heinrich Böhler, photograph ca. 1914
Vienna, Österreichische Nationalbibliothek

The collector Heinrich Böhler came from a leading industrial family and was financially independent. Between 1912 and 1915 he bought six paintings by Schiele and from 1915 supported him with a monthly payment after Schiele had been called up for military service.

spare from the 10 Kronen to pay for the streetcar to get home!" Schiele blamed the allegedly poor payment practices of his clients for his wretched financial state. His collectors and friends saw things differently. Roessler, who was constantly helping him out with larger or smaller amounts of money, finally lost patience in 1911 when, instead of thanking him, Schiele spoke disparagingly of him behind his back. Schiele explained his inability to handle money responsibly in terms of heredity: "You may be right, I am a little careless about money. I get that from my father. My father suffered from the hereditary Austrian disease, the mania for living beyond one's means."

Portrait of Franz Hauer, 1914
Drypoint etching
13 x 11 cm
Vienna, Graphische Sammlung Albertina

Franz Hauer, a butcher by trade, entered his brother in law's business and soon brought it to great prosperity. He began to collect pictures, and in particular the works of young, unknown artists. He met Schiele in 1912 and over the years bought nine important paintings.

Symbolical and Allegorical Figure Paintings

Particular significance is often given to Schiele's religious-symbolic and allegorical figure paintings. This group of works, created between 1911 and 1915, are usually multi-figure compositions, mostly in large formats. Some depict explicitly religious motifs, such as the Resurrection, or praying hermits; others represent abstract themes. An example of the latter is the painting *Pregnant Woman and Death* (1911), which in allegorical form deals with the

The Hermits, 1912
Oil on canvas
181 x 181 cm
Vienna, private collection

This painting shows Schiele in the foreground and Klimt behind him. The basic shape of the composition is triangular. Schiele said of the content: "It is not a gray sky, but a sorrowing world, in which the two figures move... this whole world, together with the figures, is intended to represent the infirmity of all living things."

subject of the danger of pregnancy: Death approaches the woman in human form. Up to 1914, Schiele considered his religious-symbolic and allegorical paintings to be his major works; he certainly took a great deal of trouble over their creation. However, many of these works, with their intensely emotional execution and their somber colors, now appear rather old-fashioned when compared to his other works.

In his most important pictures of this group Schiele still makes use of conventional themes; his painting had not yet completely freed itself from the tradition of historical painting. Historical painting, which was the most highly regarded genre in the 19th century, was used to depict well-known incidents from history and literature in a morally uplifting way; the form such works usually took was that of large, multi-figure paintings. But as modern art began to develop, historical painting became outdated. Painters such as Gustav Klimt and Ferdinand Hodler (1853–1918) tried to revive the genre with their Symbolist compositions; Schiele shared their interest and competed with his mentors in this field, too.

Roessler once aptly described Schiele's symbolic and allegorical figure paintings in the following terms: "The content of his works is not new, it is eternal; what is new is only his means of expression."

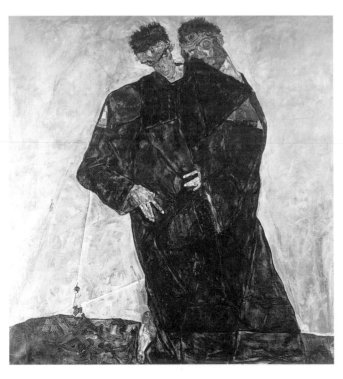

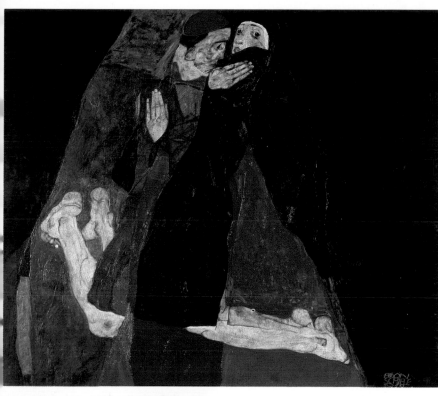

coarseness to their appearance. They are clearly abandoning themselves to forbidden emotions, for the nun is gazing wide-eyed out of the picture as if watchful or anxious, and does not allow herself to be carried away by the cardinal's passionate embrace. The topic of forbidden sexuality in the monastery or convent is a traditional theme and was in earlier times a satire on immoral Catholic priests and monks. In Schiele's painting, however, this reference plays only a subordinate role. Moreover, he probably painted a cardinal rather than a monk because the intense red of a cardinal's robe provided the contrast he needed; a brown or black monk's habit would not have created the tension and strong feeling that suffuse this picture.

Cardinal and Nun (The Embrace), 1912
Oil on canvas
69.8 x 80.1 cm
Vienna, private collection

Schiele transformed Klimt's famous painting *The Kiss* (left) by means of strongly expressive forms. The formal basis, a system of overlapping triangles, was adopted from Schiele's *The Hermits* (opposite). Instead of the golden background in Klimt's *The Kiss*, Schiele chose an impenetrably dark

expanse that conjures up a night scene. The multiplicity of Klimt's colors was reduced here to a stark interplay of red and black, the colors of love and death. The cardinal and the nun are placed in an undefined space; it is not clear what they are resting on, and whether the red surface on which the nun kneels belongs to the floor or to the cardinal's robe. They appear to float in space. Their bare legs and feet lend a certain

Gustav Klimt
The Kiss, 1908
Oil and gold on canvas

180 x 180 cm
Vienna,
Österreichische
Galerie

Years of Success 1913–1916

The year 1913 was one of artistic and financial success for Schiele. He made several trips to Krumau and to the Wachau district, and exhibited in Vienna, Budapest, Munich, Hagen, Hamburg, Breslau (now Wrocław in Poland), Stuttgart, Dresden, and Berlin. In 1914 he took part in the International Secession in Rome, his exhibits later being shown in Cologne, Munich, Brussels, and Paris. But just as his reputation as an artist was becoming secure, World War I began, in August 1914. The war, which sealed the fate of the Habsburg empire, would mark the end of an era. Yet Schiele's final years were, surprisingly, years of personal happiness, professional success, and an increasing inner peace. In 1914 he met Edith Harms, whom he married a year later after being called up for military service. During the difficult war years his duties were made easier for him by sympathetic superiors who were interested in art, and to a limited extent he was able to continue painting.

Archduke Ferdinand in his car shortly before being assassinated.

1913 The Expressionist group Die Brücke (The Bridge) is dissolved.

1914 The heir to the Austrian throne, Archduke Franz Ferdinand, is assassinated in Sarajevo. As a consequence, Austria-Hungary declares war on Serbia: World War I begins.

1915 Italy declares war on Austria-Hungary.

1916 Dadaism emerges in the Cabaret Voltaire in Zurich.

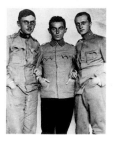

Schiele with friends in the army.

1913 Schiele visits Roessler at the Traunsee.

1914 Schiele meets Edith Harms.

1915 Schiele marries Edith Harms on June 17, and is called up for military service on June 21. He is given a desk job in the Vienna area and then made an escort for Russian prisoners of war.

1916 Schiele serves in the officers' prisoner of war camp at Mühling, near Wieselburg, and acquires a studio.

Opposite:
Russian Prisoner of War, Seated Facing Right (detail), 1915
Pencil and body color on paper
44.9 x 31.4 cm
Vienna, Graphische Sammlung Albertina

Right:
Envelope addressed by Schiele to Anton Peschka, 1913
Vienna, Graphische Sammlung Albertina

Schiele's Studios

The elegant and cosmopolitan metropolis of Vienna must have been new and exciting for Schiele when he first arrived there from the country. Soon, however, he became a typical city-dweller, enjoying the anonymity and freedom he found there to the full – so much so, in fact, that even during his stays in the country he was unable to relinquish his relaxed city lifestyle, and thus came into conflict with the locals, who were far more conventional in their outlook and behavior. It was only at the beginning of his stay in Vienna that he stayed with his uncle, Leopold Czihaczek, who lived in a superior residential area in District II, at No. 4 Zirkusgasse. This side-street of Praterstrasse is not far from the city center, and Schiele needed to walk only a few steps in order to reach the ill-ventilated, run-down courtyards of the overcrowded tenements of Vienna and so become directly acquainted with the fate of the proletariat in the big city. And it was here too that he found his models, street children and adolescent girls. The first studio Schiele rented was also in District II, in Kurzbauergasse. From 1909 to 1912 he changed his studio every year. Only in the period after his return from Neulengbach was he to find a place in which to settle down.

In the autumn of 1912 he moved into a studio in the attic of a house on Hietzinger Hauptstrasse, No. 101. Here he was to live and work for the next six years. Opposite him

Schiele's apartment and studio in the garden house in Krumau, photograph

Having set up his studio in a garden house, Schiele wrote enthusiastically to Arthur Roessler: "Dear R[oessler], Well, I have been to Krumau to look for a home and studio, and have found the most beautiful place; I will tell you all about the tulip garden and the little terrace house I am planning." And a few weeks later he told Roessler: "Yes, it is raining constantly, but it doesn't matter, I can paint the garden from my garden house." An artist called "Mopp," whom Schiele met in Krumau and invited to look at his pictures, supplied the following description: "Opposite the north railroad station, on the fifth floor of a dreary house, paintings were stacked against a chest. Paints were lying about on the windowsill and the floor was covered with heaps of drawings."

Below:
Schiele in his studio on Hietzinger Hauptstrasse, Vienna, photograph 1914

Johannes Fischer took this photograph. The display cabinet contains everyday objects that Schiele particularly liked.

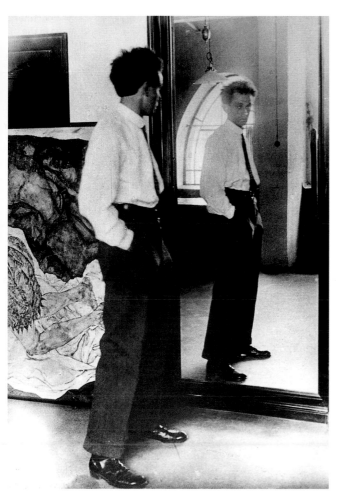

Left:
Schiele in his studio,
photograph 1915

On the left, next to the mirror, stands the painting *Death and the Maiden* (page 73).

Egon Schiele's studios:

1 1907
6 Kurzbauergasse, Vienna II

2 1909
39 Alserbachstrasse, Vienna XIX

3 1910
31 Grünbergstrasse, Vienna XIII

4 1911
14/16 Sobieskigasse, Vienna IX

5 1912
9 Rosenhügelstrasse, Vienna XIII

6 1912 Neulengbach, Au 48

7 1912 18 Höfergasse, Vienna IX

8 1912–1918
101 Hietzinger Hauptstrasse, Vienna XIII

9 1918
6 Wattmanngasse, Vienna XIII

Egon Schiele's last studio in Vienna, photograph

Schiele's last and largest studio was in the residential house, No. 6 Wattmanngasse. Because there was no cellar, the rooms were damp, which affected the quality of life there. Schiele's efforts to take over Gustav Klimt's spacious studio after his death were unsuccessful. Schiele himself designed the fittings for all of his studios. A design for a studio curtain illustrates the decisive influence of the Wiener Werkstätte (Vienna Workshop) on his interior design.

lived the Harms family, in whose daughters, Edith and Adele, Schiele became interested in 1914. After his marriage to Edith in 1915, they lived together in his studio. The cramped living conditions created tensions in 1918, since his wife found it insufferable that strange women – his models were constantly coming and going in the studio. Schiele's calendar for 1918, which has been preserved, records 177 visits by models. In order to meet his wife's objections, Schiele looked for a larger studio. As his financial circumstances had meanwhile improved, and as Edith was expecting a child, they moved to a small house in the suburb of Hietzing, which included a two story studio. Schiele planned to open a painting school in his old studio.

The Artistic Answer to World War I

World War I began in early August 1914. Schiele did not have to report for duty as his weak constitution had exempted him from military service. Soon, however, the enormous losses suffered by Austria-Hungary resulted in an acute shortage of soldiers and the army was forced to recruit without discrimination. Thus, after a further medical examination, at the end of May 1915 Schiele was classified "fit for war service." He wrote to his mother: "Suitable for reporting for duty in Prague, June 21." He and Edith were hastily married on June 17.

Everyday life in barracks was certainly a trial for Schiele, but during his three years of service up to 1918 he was particularly fortunate, for from August 1915 he was stationed near Vienna; he was never sent to the front. His superiors were understanding and made it possible for him to exercise his art, though only to a limited extent. The remote operations center at Mühling, between Györ and Bratislava (Pressburg), offered him better conditions, and his duties in the office left him enough time to paint and draw. This resulted in the drawings of Russian officers, of his superiors, and of interiors.

These works show an altered concept of art. The expressive intensity of his earlier works has given way to a greater naturalism. His

Russian Prisoner of War with Fur Hat, 1915
Pencil and body color on paper
44.9 x 30.4 cm
Vienna, Graphische Sammlung Albertina

In this precise portrayal Schiele was attempting to grasp the exotic appearance of the prisoner: the cast of his features, the oriental look of the fur hat. This drawing, with its concentration on essentials and the three-quarter view of the head, gives the impression of an ethnological study. The "Russian" is shown not as a bloodthirsty barbarian, as was customary in the propaganda of the day, but as a sensitive and intelligent human being. Despite all the precision of detail of this portrait, Schiele clearly did not want to exhaust his model's patience, and he made do with just a suggestion of his jacket. The result, which suggests a sculpted bust, lends the soldier a certain dignity.

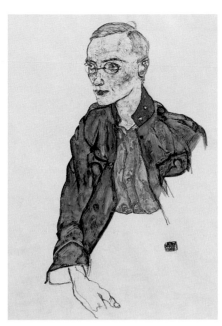

Private First-Class, One-Year Volunteer, 1916
Pencil and body color on paper
48 x 31.3 cm
Vienna, private collection

This portrait is typical of Schiele's more realistic subjects. Even the divisions in the lenses of the spectacles are recorded. It is clearly the portrait of an intellectual. The "one-year volunteers" often came from an academic background and could be distinguished from the other low-ranking soldiers by their appearance and manner. The predominantly reddish tone of the pale skin is effectively contrasted with the darker, blue uniform jacket. Schiele here shows great mastery in the interplay between fully painted areas and those only lightly indicated. He himself considered this work a success and chose it for a portfolio of 12 reproductions published in 1917. The portfolio remained the only one to have been published in Schiele's lifetime

Packing Room, 1917
Black chalk on paper
46.2 x 29.5 cm
Vienna, private collection

Dr. Hans Rosé, Schiele's superior officer, gave him the task of drawing the most important rooms of the Royal and Imperial Supply Depot. In this drawing Schiele used a broad stroke that defines objects and materials by means of an emphatic shading. The woven willow basket in the foreground is clearly contrasted with the wooden chests and the table with partly packed bottles. A

more abstract approach would not have pleased the military taskmasters, whose attitude was usually very conservative, and Schiele would have been at pains to satisfy their wishes. The many wares in the packing room create a false impression about the abundance of goods available, for throughout the country provisions were becoming increasingly scarce as World War I dragged on.

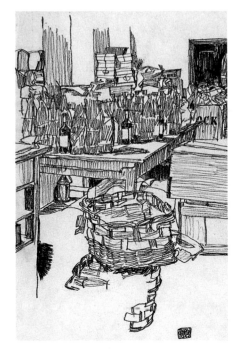

portraits give expression to a humane attitude that disregards national chauvinism and shows a real sympathy for prisoners of war. Early in 1917 Schiele was sent at his own request to the Royal and Imperial Supply Depot in Vienna, where the well-filled stockrooms were in blatant contrast to the shortages that prevailed in high street stores. Indeed, Schiele was even able to organize art exhibitions and to make important contacts with art dealers, some of whom had also ended up at the supply depot. A further transfer in April 1918 brought Schiele to the Army Museum in Vienna, where again he found time to paint. He was still working at the museum when he died later in the year.

Expressionism in Vienna

Oskar Kokoschka,
photograph 1926

Oskar Kokoschka
The Whirlwind, 1914
Oil on canvas
181 x 220 cm
Basel, Öffentliche
Kunstsammlung,
Kunstmuseum

The Whirlwind

The painting *The Whirlwind* is among the most important and expressive works of the Austrian artist Oskar Kokoschka. Its theme is his passionate relationship with his mistress, Alma Mahler (widow of the composer Gustav Mahler). The act of love is heightened to a supersensory experience that transports the two lovers. Borne along by a tempestuous wind they rush together through the dark night. The sheet on which they lie forms a whirlpool whose colors, applied with rough brushstrokes, change from blue to green and from brown to gray. The brilliant range of colors and the streaks of paint cause the surface of the painting to shimmer restlessly and so create an effective contrast to the sleeping pair. The bed sheet has formed into the shape of a shell, which is a symbol of Venus, the goddess of love. Kokoschka's "manic" painting style uncompromisingly subordinates everything to subjective emotion and the overpowering inspiration of the moment. Form and medium aim at the intense heightening of expression and emotion.

Expressionism

Expressionism is the name given to an artistic movement that flourished in the early 20th century. Expressionism was never merely an artistic style, but a new and intense awareness of life shared by a rebellious generation. It replaced what these artists considered the merely "outward form" of a subject, as depicted by academic art, with a subject's "inner form," a form revealed by intense feeling; for Expressionists only this inner form possessed true powers of revelation. The reality that could be perceived by the senses was understood only as a transitional stage to that perceived by the soul. The work of art should provide not merely an aesthetic pleasure, but a profound, elemental, soul-stirring experience. The expressive qualities of medieval art, with its non-naturalistic figures, spaces, and colors, the art of "primitive" peoples, with their masks and demons, and the colorful quality of folk art were all rediscovered and transformed into individual styles. Among the most important representatives of Expressionism were the painters of the Die Brücke (The Bridge) in Dresden and Der Blaue Reiter (The Blue Rider) in Munich. Major figures include Emil Nolde, Christian Rohlfs, and Max Beckmann.

Expressionism in Vienna

Expressionism occupies a special position in 20th-century Austrian art. It was not promoted by groups of artists, as in Germany, but was represented in the first instance by the two major personalities of Viennese art, Oskar Kokoschka and Egon Schiele. They became the leading Austrian representatives of Expressionism, and to this day their names remain linked with the Austrian form of this distinctively 20th-century artistic sensibility. The multitalented painter and dramatist Kokoschka exhibited at the Vienna Kunstschau and immediately achieved a *succès de scandale* with his nude pictures of young girls. His Expressionist drama *Murderer, Hope of Women* (1910) confirmed his reputation as the *enfant terrible* of Viennese society. Sadly, the relationship between Kokoschka and Schiele was overshadowed by their rivalry. The two artists in fact had little contact with each other since Kokoschka worked mainly in Germany. Both moved beyond the decorative style of their common mentor, Gustav Klimt, though both showed a continuity of content. The distinctive character of Austrian Expressionism lies among other things in its strong tendency towards basic human themes such as death and sexuality; pairs of ecstatic lovers are seldom found in German Expressionism.

A pollution of my love – yes. I loved everything. The girl came, I found her face, her unconscious, her worker's hands; I loved everything about her.

Egon Schiele, 1910

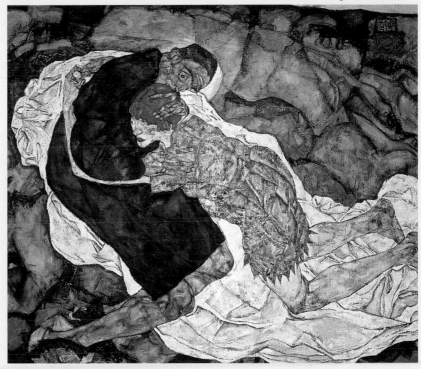

Death and the Maiden

This picture (above) has had three titles in the course of its history. The two others – *Man and Maiden* and *Entwined Couple* – show that Schiele was not thinking only of the conventional Death and the Maiden theme, which has been frequently represented since the Middle Ages; he did not want to be limited to a traditional interpretation. The parallels in motif, form, and format with

Kokoschka's *The Whirlwind* are obvious; the lovers are certainly posed in a very similar way. But there are important differences in color and expression. With Schiele, the couple's embrace is not rapturous nor ecstatic, but profoundly melancholy. A hint of the death motif underlines the finite nature of their relationship. The man is a self-portrait of Schiele, and the model for the woman is Wally Neuzil. The picture

Death and the Maiden (Man and Maiden), 1915
Oil on canvas
150 x 180 cm
Vienna, Österreichische Galerie

was painted in 1915, the year in which they finally broke up. Through the symbol of death Schiele seems to be introducing a note of fatefulness into their relationship. Shortly after this picture was painted he left her.

The Benesch Double Portrait

You have already promised twice to draw me, but so far… you have not kept your promise. You have done this favor for all your artistic friends, but not for me. How have I, of all people, deserved to be excluded?

Heinrich Benesch, 1913

How the portrait came about

This double portrait was painted at the urging of Heinrich Benesch, who in March 1913 complained bitterly that he had not yet been portrayed by Schiele. The latter reassured his friend, and in the same year painted the double portrait of Heinrich Benesch and his son. Otto (1896–1964), Benesch's only son, studied art history and later became a well-known art historian. From 1947 to 1962 he was director of the Albertina in Vienna and throughout his life was a staunch supporter of Schiele's work. The relationship between father and son was complicated. Heinrich Benesch was a strong-willed and patriarchal figure, and was not particularly impressed by his son's intellectual leanings.

Study for the Benesch Double Portrait, 1913
Drawing
47 x 30.8 cm
Cambridge (Mass.), Fogg Art Museum

Composition and structure

The portrait is square in format. The two figures, placed in front of an empty background, almost completely fill the painting; the edge of the picture cuts off the legs of both men and the top of the younger man's head. The father has his back turned to the observer and is stretching out his left arm to place his hand on the shoulder of his son, who is seen from the front. Heinrich Benesch's arm cuts across the picture like a barrier, a powerful image of his dominant role in the father-son relationship. Otto Benesch, by contrast, has folded his hands in front of his body, and makes no response to his father's gesture, which is one of affection but also of power and superiority. Schiele worked deliberately on the contrasts between the two figures. Otto is taller than his father; his face is slender. Heinrich Benesch has a massive frame and a square skull. His face looks strong, rugged, and mature, while Otto's is still youthful. The father's expression is energetic, the son's contemplative. The two men do not look at each other.

Benesch Double Portrait, 1913
Oil on canvas
121 x 130 cm
Linz, Neue Galerie der Stadt Linz

Schiele had prepared various studies for this picture. First he intended that the two men should stand side by side, or that the father should sit beside his standing son. Finally he rejected these rather conventional arrangements and executed the work as seen here. There are two designs for the composition in Schiele's sketchbook in the Albertina in Vienna that show Heinrich Benesch's left arm extended horizontally. With this concept Schiele created one of his most remarkable figural compositions. This double portrait has a graphic quality, the lines and outlines that define the forms determining its overall impression. The background encloses the figures in light-colored surfaces that contrast strongly with the black outlines of the figures. The colors, apart from the red in the heads and hands, are restricted to browns and ochers. In his memoirs, the son, Otto Benesch, described the long preparatory sessions: "Schiele drew rapidly; his pencil glided, as if guided by a spirit hand, over the surface of the white paper, in a manner which was sometimes like the brushstrokes of East Asian painters. He used no eraser – if the model changed position, he placed the new lines next to the old ones with the same unerring certainty. Incessantly one sheet of paper replaced another, and so the process hurried on… But his greatest masterpieces came into being as if in play, the artist adopting the most relaxed, nonchalant, even awkward position. But how Schiele's dark eyes bored into the model! How he caught the nature of every nerve and muscle!"

Otto Benesch's wife later surmised that in this double portrait Schiele had - consciously or unconsciously – understood the hidden psychological tension in the relationship between father and son. The father liked to dominate, and so the intellectual awakening of the son would have been uncomfortable for him." Schiele already sensed in the youth… beyond all outward barriers, his insight into the world of the intellect, and he expressed this in his portrait. It was an intellectual world in which Otto Benesch quite naturally dominated." One is tempted to read into the father's gesture one last demonstration of his authority. What is important above all else is that Schiele provides a psychological description of the two men in his double portrait, and subordinates the whole composition of the painting, the room and the clothing, to this overriding theme.

Return to Vienna

At the beginning of 1917 Schiele was transferred to the Konsumanstalt (food depot) in Vienna. Now he had time to think about what he should do after the war. A new beginning was in the air: Schiele had in mind the foundation of an artists' working co-operative gallery, in which visual artists, musicians, and writers could come together. The composer Arnold Schönberg, the artist Gustav Klimt, and the architect Josef Hoffmann and many others were to help to build the nation anew. Sadly, this ambitious project never passed the planning stage.

By 1918 Schiele had undergone a change of style that in the end brought him wider public recognition. After Klimt's death in the spring of 1918, Schiele was for a short time the most important painter in Austria. His rise to fame was cut short by a terrible epidemic, to which 20 to 25 million people worldwide fell victim: Spanish influenza. A month before the end of the war, Edith, now pregnant, died; Schiele died three days later, on October 31.

Proclamation of the republic of Austria, 1918

Schiele beside his painting _Encounters_

1917 The Russian Revolution begins.

1918 Almost 25 million people worldwide fall victim to Spanish influenza. Gustav Klimt dies on February 6.

1917 Schiele serves in the Royal and Imperial Supply Depot.

1918 Schiele is given the main hall in the 49th Exhibition of the Vienna Secession. His wife, Edith, dies on October 28 of Spanish influenza, and three days later, on October 31, Egon Schiele himself succumbs to the epidemic.

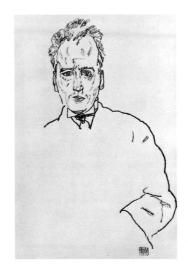

Opposite:
Embrace (detail), 1917
Oil on canvas
100 x 70 cm
Vienna, Österreichische Galerie

Right:
Anton Webern, Composer, 1918
Pencil on paper
49.1 x 30 cm
Private collection

Edith Schiele

Edith Schiele, born in Vienna, came from a solidly middle-class family. Her father was from the Hanover area and had worked in a locomotive factory until his retirement in 1914. Edith, like her sister Adele, who was three years older, had been educated at a convent and spoke fluent French and English. Beyond her school education she does not seem to have undertaken any professional training. She was still living in her parents' house when Schiele first met her. Before agreeing to marry him, she insisted that he should break off his relationship with Wally Neuzil. Schiele bowed to her wishes and ended the relationship with Wally, who had been his friend, lover, and model for several years. Wally was badly hurt by this rupture, for she herself had remained loyal to him in difficult times. Because Schiele was unexpectedly declared fit for military service at the end of May 1915, his marriage to Edith took place in great haste, on June 17. During the months that followed, Edith accompanied him on the various postings of his military service, his final posting bringing them back to Vienna. In spite of their different backgrounds the marriage developed into a loving relationship that found artistic expression in Schiele's last great work, *The Family* (page 83). Schiele made several portraits of Edith, and in fact she became his chief model, though in nude studies she demanded that her

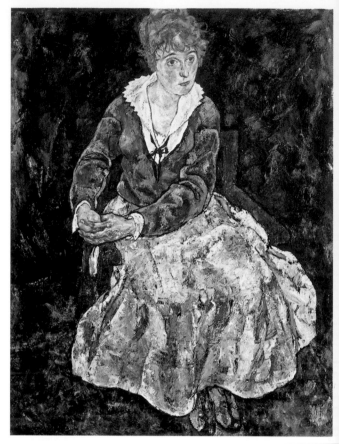

Portrait of the Artist's Wife, Seated, 1918
Oil on canvas
139.5 x 109.2 cm
Vienna, Österreichische Galerie

This portrait of Edith Schiele, painted in 1917, was reworked a year later. The director of the Staatsgalerie in Vienna said he would buy the picture, but only on condition that Schiele overpainted the colorful checked skirt. Schiele agreed and covered the ornamental pattern with thick layers of paint. The skirt was now almost one color, but in a few places the original yellow, red, and green still shine through. The seated figure is composed so that the head, following the axis of the body, looks to the (viewer's) right, while the upper part of the body is turned sharply in the opposite direction. The shoulders and arms form an oval shape. Schiele's main concern in this period of his creativity was to achieve greater freedom as a painter. Painted in a rich impasto, the skirt and background have an almost abstract quality.

face should not be recognizable. In the middle of October 1918 she became ill with Spanish influenza. Schiele informed his mother: "Edith has become ill, and has also got pneumonia. She is also in the sixth month of her pregnancy. The illness is very severe and life-threatening; I am already preparing myself for the worst." She died the next day.

Passport photograph of Edith Schiele, 1915

Like this photograph, all the portraits of Schiele's wife show her with a rather serious, composed expression.

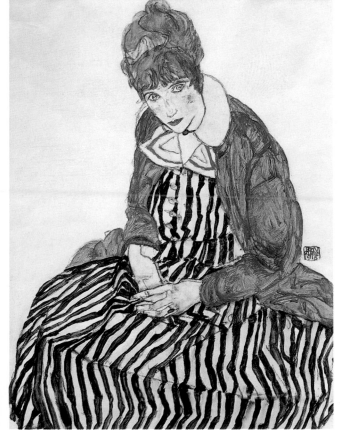

Edith Schiele, Seated, 1915
Pencil and body color on paper
51 x 40 cm
Vienna, private collection

During World War I, Edith Schiele and her sister Adele, because of the shortage of good fabrics, sewed dresses for themselves from the striped curtains in Schiele's studio. Schiele was fascinated by the pattern of these garments, and painted both sisters wearing them. In the same year he painted a further, life-size portrait of Edith, which shows her, standing, in the same dress, which has now become a colored one, as he transformed its stripes into various colors. Schiele succeeds in giving this picture greater mass just by means of the black-striped pattern. So as not to counteract this effect, he painted the hair and jacket the same color. In all his drawings and paintings of Edith, Schiele manages to capture her gentle, rather melancholy charm.

Hand Signs

*I, the eternal child – I made sacrifices to others,
those who were far away or did not see me, the
seer. I brought gifts, sent my eyes… toward
them, I made the roads before them easier to
travel, and – did not save them. Soon, some of
them recognized the gestures of the visionary,
and then they asked no more.*

Egon Schiele, 1911

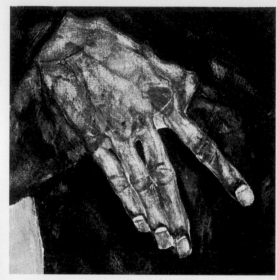

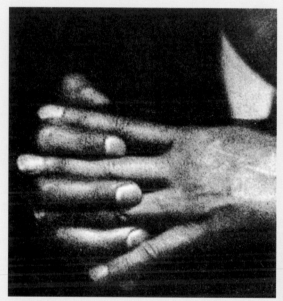

Left:
**Egon Schiele with clasped
hands** (detail), photograph
1912
Anton Trčka (page 37,
top right)

Above:
The Hermits (detail)
1912 (page 64)

Right:
***Self-Portrait with Black
Earthenware Pot*** (detail),
1911 (page 37, below left)

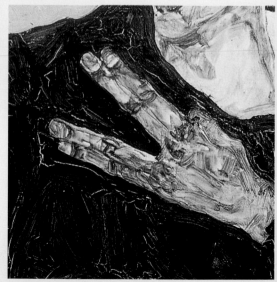

Hands in Schiele's works

Schiele devotes a great deal of attention to the depiction of hands. Hands and gestures can strongly determine the character of a picture, and in Schiele's case they often deepen the expressiveness of many of his self-portraits. This particular interest in hands is not new in art; but Schiele repeatedly shows the same gesture: the extended fingers spread out in a V-shape. It is particularly in his self-portraits that he depicts this preferred gesture; even photographs of Schiele show him making unusual hand gestures. The meaning of his preferred gesture, which over the years appears in many of his paintings, is not clear; on the contrary, it still appears mysterious and enigmatic. Particularly in *Death and the Maiden* (right) and *Embrace* (above) it is striking that the hand gestures and facial expressions do not form a comprehensible unity. The hands seem to strike a pose of their own, and the facial expressions do not show the emotional states we might think appropriate to the situation.

The pathology of art

Though this gesture remains mysterious, we do know that there is a historical background to it: the "medical" significance of such hand signs. In the 19th century researchers developed a keen interest in what is now known as the "pathology of art." This involved the incorporation of medical knowledge, above all from the realm of psychiatry, into art. It was assumed that in an advanced, technological world only mentally ill and "primitive" people were capable of expressing pure, genuine feelings in their gestures and facial expressions.

Schiele and many other artists drew from the pathological repertoire of gestures recorded in photography and documented in textbooks in order to achieve "original" means of expression not conditioned by social conventions. However, exactly how Schiele's hand signs are to be traced back to these pathologies is not clear.

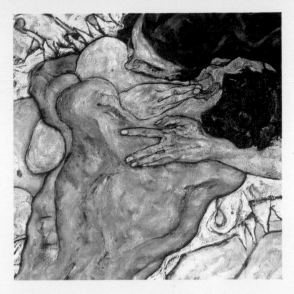

Above:
Embrace (detail), 1917
(page 76)

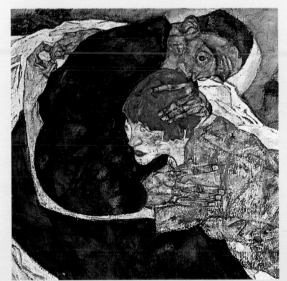

Death and the Maiden
(detail), 1915 (page 73)

The gesture adopted by the hands of Death, who tenderly takes the girl in his arms, is the "hand sign" most frequently reappearing in Schiele's work. In connection with the theme of Death and the Maiden, however, Death's hand gesture does not become more comprehensible. Moreover, the picture makes it clear that facial expression is also of no help in interpreting this gesture, for this too is ambiguous.

The Family

Mother with Two Children II, 1915
Oil on canvas
149.5 x 160 cm
Vienna, private collection

**Blind Mother
(The Mother I)**, 1914
Oil on canvas
99 x 120 cm
Vienna, private collection

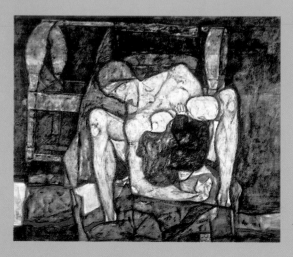

The origin of the mother and child pictures

Schiele had been working on the juxtaposition of the themes of death and motherhood since 1910. Examples include *Pregnant Woman and Death* (1911), in which Death appears to the woman in the guise of a monk, and *Dead Mother I* (1910). It has been suggested that his difficult relationship with his mother may have been the prime reason for his dark interpretation of the traditional mother and child theme. It is important to remember, however, that he painted several positive interpretations of motherhood, including *Young Mother* (1914) and the very decorative *Mother with Two Children II* (top left), which in its vivid, expressive colors reminds us of Schiele's love of folk art.

Composition

With the addition of a man, Schiele transforms the mother and child theme into an image of the family. In *The Family* (opposite) the figures are arranged frontally. Because his left arm is extended to rest on his updrawn knee, the gaunt figure of the man creates a sense of movement that balances the stillness of the woman.

The couple and the child are lit as if by a shaft of light, while the bed and the room remain in darkness, so that the figures seem crowded together in the foreground.

Interpretation

At the exhibition held by the Vienna Secession in 1918 this painting was shown under the title *Crouching Couple*. The new title suggests that Schiele may have had the theme of the Holy Family in mind. However, since the male figure is unquestionably a self-portrait and Edith Schiele was pregnant at the time he was working on the painting, the work can be interpreted as a depiction of the "death" of their exclusive relationship: in other words the lovers were becoming a family. In 1917 Schiele had painted *Embrace* (page 76), which shows a naked couple lying on a white blanket, embracing tightly, a

Egon Schiele and Edith, photograph 1918

depiction of erotic love-play that was very daring. In comparison with such earlier depictions of human sexuality, it might seem that in *The Family* Schiele was now concerned with the traditional allocation of roles between the sexes. In fact it is unlikely that his main concern here was to make a direct commentary on personal or social roles. Nevertheless, it has to be admitted that the relationship of the couple in *The Family* is a conventional one. The man, enclosing the woman and child in a protective gesture, looks directly at the world outside; the mother and child, by contrast, are inwardly directed and form a closed

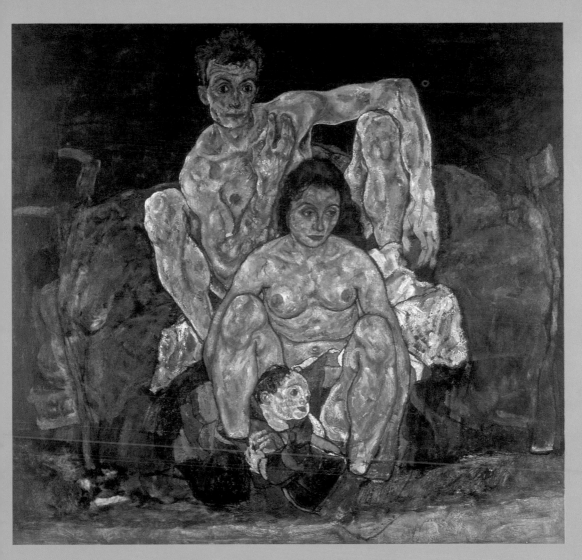

unity from which the man is excluded. The intimate setting, with the couple sitting naked on a bed, is certainly very unusual for such a family scene.

The Child

It is striking that the child is not shown naked, and also that the blanket in which he or she is wrapped covers the mother's genitals, despite her widely spread thighs. Schiele was thus not concerned here with the sexual relationship of the man and woman, but with their role in the family. The figure of the child was added at a later stage, after Schiele had learned of his wife's pregnancy. She died before giving birth.

The Family, 1918
Oil on canvas
152.5 x 162.5 cm
Vienna, Österreichische Galerie

Posters and New Paths in Typography

The artist poster, created for the promotion of his or her own exhibitions, had great significance for Schiele. Throughout his career he designed posters and created the posters for all his exhibitions.

The poster was now developing rapidly as an art form; in particular, the Expressionists in Austria and Germany wanted to free the poster from its craft-related constraints. The poster was not only to act as an advertisement for an exhibition, but also to be a work in its own right, a

Bottom left:
Poster: Horse and Rider, 1915
Chalk and gouache on paper
95.5 x 60 cm
Vienna, private collection

The style of the poster is strongly reminiscent of a child's drawing. This is no accident, for in the wake of contemporary psychological research a keen interest had developed in the pictures produced by children and the mentally ill. It was hoped that insights could be gained from these artworks about the intellectual development of the child and also about the human psyche. The horse looks like a wooden toy horse, and the rider, with his colorful headdress, like a king. In this very crude, simplified design, Schiele has incorporated influences from traditional folk art, which he collected. He is not interested in a symbolic message, such as were usually conveyed by exhibition posters; his image is essentially a simple one. The alternation of black and white letters is a particularly effective device.

Above:
Poster: The Poor People in the Erzgebirge, 1913
Body color on paper
31.2 x 22.5 cm
Vienna, Graphische Sammlung Albertina

The equal importance Schiele accorded to text and image is well illustrated by this poster of 1913. Schiele designed it for an exhibition at the Vienna city hall about poverty in the Erzgebirge, a mountain range between Bohemia and Germany. The design consists of three horizontal bands, of almost equal width. The black rim does not extend to the edge of the sheet but leaves a narrow strip of unprinted paper on all sides, which produces the effect of a light-colored frame. The actual area of the image is only a little larger than the two areas of text. In these the black letters are placed so that they touch each other and the black rim. This produces an optical impression of filigree work enclosing the image. The composition throughout is comparable to that of an ornamental carpet design. The Expressionist Ernst Ludwig Kirchner (1880–1938) created designs for wall carpets that were executed by craftswomen – perhaps Schiele was inspired by these woven carpets.

product bearing the unmistakable stamp of an artist's style.

Schiele's printed posters show that in the course of his artistic evolution he was developing a flair for this medium and felt inspired to invent his own independent language of forms and typography. Apart from Oskar Kokoschka's posters, Schiele's are the best-known examples of the Expressionist poster in Austria.

A characteristic of nearly all of Schiele's posters is that they are encompassed by a black, irregularly drawn edge that frames both images and lettering. Typically, the poster is divided into areas of varying size, with areas containing images and areas containing text being kept separate.

Schiele clearly gave as much importance to typography as to image. He developed his own calligraphy, using broad, heavy characters, which in the course of time became more and more simplified. The "written image" became a means of expression and not just a source of information.

Compared to those of Kokoschka, who wanted his posters or "notices" to make a direct impact on the viewer and so largely conformed to conventional practice, Schiele's designs are less traditional in their approach, particularly the colored ones. One of his most famous posters, for example, for the 49th Exhibition of the Secession (right), which is made up of several elements, has few of the characteristics of the traditional poster.

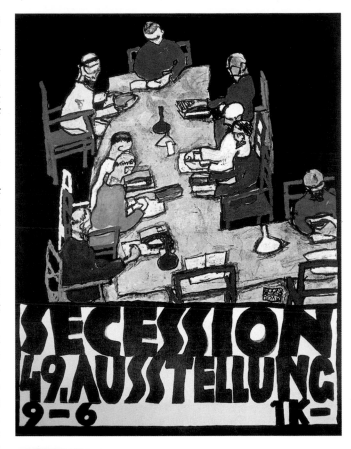

Poster for the 49th Exhibition of the Secession, 1918
Color lithograph
68.3 x 53 cm
Vienna, Historisches Museum der Stadt Wien

This poster shows a long table around which nine people are seated; two chairs are empty. On the table in front of the figures, which are depicted in a greatly simplified form, are papers and bottles. In this design Schiele is referring to an unfinished painting called *The Friends*, in which he depicted a gathering of his painter friends. In *The Friends* he himself sits right at the top on the narrow side of the table, and opposite him at the other end of the table a bald-headed man is seated. Because this figure, seen from behind, is missing from the poster, it is assumed that in the painting it represents Gustav Klimt. Klimt had died before the opening of the 49th Exhibition of the Secession and his seat at the table was therefore vacant. This motif, of an evening meal shared by friends, is a traditional one.

The Signature: the Artist's Fingerprint

Artists' signatures, which have existed since antiquity, are a statement of authorship. Schiele gave great attention to his signature and developed it in the course of his career into an independent graphic sign. The signature became his "fingerprint." Using bold, simplified letters, Schiele combined his forename and surname and the year of the work (sometimes enclosing them in an emphatic frame), the result being reminiscent of a brand or the impression made by a rubber stamp. Creating an unmistakable trademark with his signature, he was at the same time expressing his artistic self-assurance. According to the importance of the work, he added one or more identifying marks. The painting *My Room* (page 51) includes as many as three signatures, alerting us to the high value this work had for Schiele. By contrast, *The Family* (page 83) has no signature, though it was exhibited in 1918, so was considered ready to be seen; he probably thought the work not quite finished and intended to do a little more work on it. Beyond proof of authorship, the signature has a further function in Schiele's graphic work. Usually he places his signature so that it can be read without any difficulty. But with some of Schiele's drawings this is not so, for he sometimes signed the sheet so that it has to be turned in order for his signa-

Schiele's signature from the year 1912

Schiele's signature from the year 1915

Schiele's signature from the year 1918

ture to be read. This means that we see the image from the "wrong" point of view. A good example is *Woman with Blonde Hair Lying Down* (right), where the model is shown in a horizontal position. Here Schiele placed his signature so that we have to turn the paper through 90 degrees in order to read it (as it appears here). This transforms the horizontal format into a vertical one, and we now see the reclining woman from a completely new angle, namely from above. The body now appears contorted. In placing his identifying mark on the sheet in this way he deliberately changed the drawing's orientation, thus indicating to the viewer how he, the artist, wanted the image to be seen. Here Schiele was freely experimenting with the handling of a subject. Simply by turning the sheet, and thus transforming the *Woman with Blonde Hair Lying Down* into one who is somehow "on her feet," he deliberately challenges our perceptions of an image.

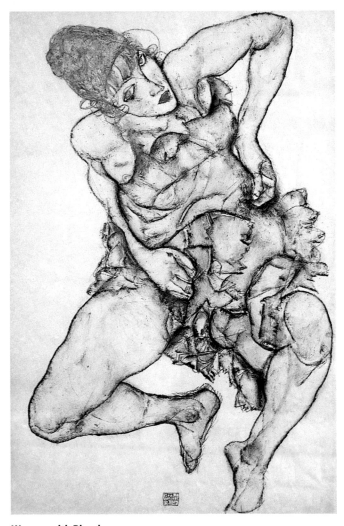

Woman with Blonde Hair Lying Down, 1914
Gouache, watercolor, and pencil
31.7 x 48.5 cm
Private collection

Above:
Exhibition poster for the Seibu Museum of Art, Tokyo, 1979

Right:
Mother and Child, 1910
Gouache and pencil
55.6 x 36.5 cm
Vienna, Historisches Museum der Stadt Wien

Exhibitions after 1945

1948 New York, Galerie St. Etienne

1948 Vienna, Academy of Fine Arts

1960 Boston, Institute of Contemporary Art

1965 Florence, Palazzo Strozzi

1968 New York, Salomon R. Guggenheim Museum

1970 London, Royal Academy

1995 Tübingen, Kunsthalle

1996 Hamburg, Kunsthalle

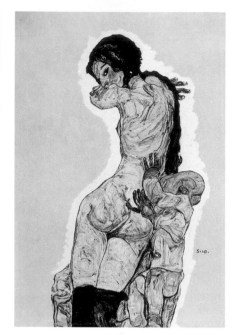

Recognition and Posthumous Fame

Schiele's lack of success in his lifetime has always been exaggerated; the 49th Secession exhibition of 1918 in Vienna was in fact a great success – he certainly sold a substantial number of the 50 pictures he exhibited. However, Schiele was still too young to exert any influence on other artists. He himself had been firmly convinced of his own importance and had intended to teach others; his plan to turn his studio into a school was prevented by his early death.

The shattering of social conditions in the Austrian republic after World War I did not provide a favorable climate for a measured assessment of his work. Nevertheless, small gallery exhibitions of his works were regularly mounted in Vienna in the 1920s. But then the social and political developments in Germany from 1933 onwards, and the so-called Anschluss of Austria (its annexation by the Third Reich) in 1938, led to his work being condemned as "degenerate."

However, art historians such as Otto Benesch made sure that Schiele's works were acquired by public collections and that the Egon Schiele archives of the private collector Max Wagner ended up in the collections of the Albertina in Vienna.

In 1945 the first Schiele exhibition in the USA was held at the Galerie St. Etienne, New York, but it aroused little attention. For in the wake of World War I, abstract art came to be preferred by the leading Western countries, and only those artistic developments that had prepared the way for abstraction were in the public eye. Schiele's painting could not readily be fitted into this line of development, and again found itself on the sidelines.

But with the rise of Pop Art in the USA and Great Britain – a movement that rejected abstract art and restored the objective portrayal of the world to artistic primacy – public and critical attention turned to those movements that had not been part of the "irresistible drive to abstraction." Conditions were now right for the wider reception of his art and Schiele's work was once again in demand.

Nonetheless, his work attained international fame only when the English-speaking public began to be interested in it. In the early 1960s three big exhibitions in the USA and one in London made Schiele better known. While today his works command very high prices, in the 1960s they were still to be had for a reasonable amount: in London in 1964 a gouache sold for £2,000.

Schiele's work comprises some 300 paintings, 17 etchings and lithographs, two woodcuts, several sculptures, and 2,000 to 3,000 drawings, watercolors, and gouaches. Sadly, a large part of this enormous body of work, which is preserved in various public and private collections throughout the world, is rarely seen because of the considerable damage it has suffered over time. Moreover, for reasons of conservation these very sensitive works cannot be exposed to light for too long, and are therefore kept in storage most of the time. So when important graphic collections such as that of the Albertina in Vienna now open their collections of works by Schiele there is huge interest. At one time such exhibitions of graphics aroused little interest; only a small circle of art lovers were enticed by them. Today they attract as many visitors as large exhibitions of paintings.

Above:
The picture *Girl* was sold at the Vienna Auction Houses on June 6, 1998, for $ 3,434,100.

Auction prices achieved by Schiele's works

1987
Sotheby's, London
Portrait of the Artist Anton Peschka
$ 2,576,000

1996
Sotheby's, New York
Portrait of a Woman in a Black Hat
$ 2,700,000

1997
Sotheby's, New York
Bekehrung (Conversion)
$ 3,100,100

1998
Vienna Auction Houses
Girl
$ 3,434,100

1998
Christie's, New York
Summer Landscape
$ 3,312,884

Photograph of an exhibition at the Graphische Sammlung Albertina, Vienna, 1991

Collections and Collectors

The Graphische Sammlung
Albertina, Vienna,
photograph 1999

**The seal of the Egon
Schiele Archive from the
Graphische Sammlung
Albertina, Vienna.**

**The graphics collection at
the Albertina**

Through donations and
purchases, the Albertina in
Vienna has assembled a
collection of Schiele's works
that is unique. It consists of
more than 150 drawings
and watercolors,
sketchbooks, graphic works
ready for printing, and,
importantly for research
into Schiele, an outstanding
archive of documents on the
artist's life. Among these, for
example, are original
drawings from his time as a
student at the Academy. As
early as 1917 the
Staatsgalerie in Vienna
bought some sheets of
Schiele's that later ended up
in the Albertina and formed
the basis of the archive.
Purchases from Arthur
Roessler's collection and the
estate of Heinrich Benesch,
and generous gifts, for
example by Erich Lederer,
extended the Schiele
collection at the Albertina.
Today Schiele finds himself
in the company of the most
important artists of the
western world. Nearly all the
notable artists in Christian
art history from the 15th
century to the present day
are represented in the
collection. The drawings of
Albrecht Dürer (1471–1528)
– in particular the world-
famous *Young Hare* (1507) –
are among the most
illustrious items in the
collection. Other famous
artists represented here are
Leonardo da Vinci
(1452–1519), Raphael
(1483–1520), Michelangelo
(1475–1564), Pieter
Brueghel (1525/30–1569),
Rembrandt (1606–1669),
Francisco de Goya
(1746–1828), Paul Cézanne
(1839–1906), and Pablo
Picasso (1881–1973).

In 1776, the combination
of the collections of Duke
Albert of Saxony-Teschen
(1738–1822) and the prints
cabinet of the Imperial court
library resulted in the
foundation of the
Kupferstichkabinett
(engravings collection) of
the Albertina. It now
contains the largest
graphics collection in the
world: 44,000 drawings and
watercolors, as well as some
1.5 million prints.

The wrought-iron gate in front of the Egon Schiele Museum in Tulln, 1998

The Egon Schiele Museum in Tulln

In 1990, on the centenary of Schiele's birth, the Schiele Museum was opened in his native town, in the former district prison on the banks of the Danube. The International Egon Schiele Society had decided to commemorate the town's most famous son by providing visitors with a guide to his life and work. Here the emphasis is mainly on his youth and time at the Academy, but the later stages of his artistic career are also examined, in the section called "Schiele and his Time" on the first floor. On the second floor, 90 original works and a number of reproductions are shown. The choice of Tulln's former prison building, which had stood empty since 1961, as the site of the museum, recalls Schiele's period of

detention in prison at Neulengbach. This is why the careful remodeling of the prison as a museum included the retention of the fabric of the original building, including its prison cells.

The Leopold Collection

The art historian Rudolf Leopold is one of the most important private collectors of Schiele and other Austrian artists of the 19th and 20th centuries. Here Egon Schiele's work is represented in all its phases. Leopold encountered the artist's work in the 1950s through an old and very rare exhibition catalog, and was immediately captivated. By 1945 many pictures were outside Austria, mostly in the possession of Austrians who had had to emigrate during the Nazi period. With utmost commitment and endless patience Leopold succeeded in assembling his collection over four decades. Up to 1995 he performed the outstanding service of promoting Egon Schiele and his contemporaries outside Vienna and the borders of Austria. Since 1996 his collection has entered a private foundation and is

now permanently accommodated in the Leopold Museum in Vienna. The museum is to be moved to a new building in the Vienna museum district, which is to be completed at the beginning of the new millennium, and of which Leopold is to become director. This collection, with over 5,000 items in all, comprises 44 oil paintings and over 200 drawings, watercolors, and gouaches by Schiele. In addition there are works by Schiele's contemporaries such as Gustav Klimt, Oskar Kokoschka, Richard Gerstl, and Herbert Boeckl. As a Schiele expert, Rudolf Leopold is often called upon by auction houses to authenticate previously unknown works by Schiele, for after Schiele's death his business-minded brother-in-law added color to many of his drawings.

Gustav Nebehay
The art dealer Gustav Nebehay (1881–1935) met Schiele in 1917 and later administered his estate. His son, Christian Nebehay, publicized the Schiele archive in two books (1979 and 1989).

Glossary

Abstract art Any art in which the depiction of real objects in the world has been replaced by a concern with the purely formal elements of art – in the case of painting, for example, with a concentration on the intrinsic values of shape, color, line, etc. Among the major pioneers of abstract art were Wassily Kandinsky, Kasimir Malevich, and Piet Mondrian.

Academies Art academies were associations of artists organized into professional institutions; education and training were always of central importance. The first official art academy was the Accademia del Disegno founded in Florence in 1563 by Giorgio Vasari. In time influential national academies were formed, such as the French Académie Royale (1648) and the British Royal Academy (1768). Training was based on the close study (imitation) of classical Greek and Roman works, and by the 19th century academies had become associated with all that was conventional, superficial, imitative, and unprogressive.

Blaue Reiter, Der ("The Blue Rider") A group of Expressionist artists formed in Munich in 1911 and named after an almanac published by Wassily Kandinsky and Franz Marc. Other leading members included August Macke, Paul Klee, Gabriele Münter, and Alexi von Jawlensky.

Brücke, Die ("The Bridge") A group of Expressionist artists formed in Dresden in 1905. Their works were characterized by strong colors and simplified, almost crude images that resembled those of woodcuts. It was dissolved in 1913.

Classical antiquity Ancient Greece and Rome, from approximately the 5th century BC to the 4th century AD. From the Renaissance onward the styles and themes of the art of classical antiquity provided the basis of art training in academies throughout Europe. The Neoclassicism of the 18th century was based on a direct and systematic revival of classical antiquity.

Composition (from the Latin *compositio*, "placing together") The art of combining the elements of a picture into a satisfying visual whole. The elements include color and form, line, symmetry and asymmetry, movement, rhythm, etc.

Contour The outline of a form, produced either by a line or by means of contrast.

Drypoint An engraving technique in which the design is cut into a plate by a hard metal point. A burr is turned up by the metal point and it is this that retains the ink for printing, hence the characteristic fuzziness of drypoint prints.

Expressionism An artistic movement of the first half of the 20th century, notably in Germany and Austria. Stressing the importance of conveying intense subjective experience rather than the exact or realistic depiction of objects, Expressionists developed a simplified style characterized by flat, simplified or distorted forms, very strong colors, and vigorous brushwork. Leading Expressionists included Ernst Kirchner, Franz Marc, August Macke, Max Beckmann, Edvard Munch, and Emile Nolde. Precursors include Vincent van Gogh and James Ensor.

Gouache A watercolor paint made opaque by the addition of white pigment. Unlike true watercolor, which creates transparent effects, gouache produces dry, opaque, pastel-like colors. Also known as poster paint.

Graphics Any of the visual arts based on drawing or the use of line rather than color. Examples include drawing, engraving, woodcut, and etching.

Hatching In a drawing, printing, or painting, a series of close parallel lines that create the effect of shadow, and therefore contour and three-dimensionality. In *cross-hatching* the lines overlap.

Highlight An area of brightness in a painting or drawing. In traditional drawing practice it was often created by the use of white chalk.

Historical painting The genre of art concerned with the depiction not only of real historical events but also of mythological, biblical, religious, and literary events. Until the end of the 19th century historical painting was considered the most important genre of painting, being morally elevating, followed by the portrait and the "lower genres" of landscape, genre, and still-life.

Impasto Oil paint applied very thickly, with a brush or palette knife, creating a richly textured surface.

Impressionism A movement in painting that originated in France in the mid-1860s. Attempting to capture the ever-changing effects of light, Impressionists used a free style of brushwork and colors that are light and bright. The preferred subjects were taken from everyday life and were presented informally rather than posed or arranged.

Jugendstil The German term for Art Nouveau, a decorative style that developed during the 1890s. It is characterized by flowing lines and highly ornate plant motifs. It influenced design, crafts, and architecture as well as painting and sculpture. The term Jugendstil is derived from

the journal *Die Jugend* (German for "Youth"), first published in Munich in 1896.

Landscape painting The depiction of natural scenes. While landscape had at first been only an accessory to the depiction of figures, it developed at the end of the 16th century into an independent genre of painting. During the 17th century so-called ideal landscapes (such as those of Claude Lorrain) and heroic landscapes (such as those of Nicolas Poussin, in which scenes from history or mythology were shown) gave landscape painting greater status. Landscape painting reached a high point in 17th-century Holland, where the naturalistic landscape was favored. Landscape painting was revolutionized by the rise of open-air Impressionist painting during the 19th century.

Motif The central theme of a work of art or literature; a recurrent thematic element or image in a work.

Neoclassicism A style in art, architecture, and design that flourished 1750–1840. It was based on the revival of the styles and subjects of classical antiquity.

Oil painting A painting technique in which color pigments are bound with a natural oil, such as linseed. Oil paints are smooth and creamy and can be worked together easily, producing a wide range of subtle tones and colors. Oil paint can be applied in thin, transparent layers or very thickly. Oil

painting developed in the 15th century and has since been the predominant medium in European painting.

Perspective (from the Latin *perspicere*, "to see through, see clearly") Any method of representing three-dimensional objects on a flat surface. Perspective gives a picture a sense of depth. The most important form of perspective is *linear perspective* (first formulated by the architect Brunelleschi in the early 15th century), in which the real or suggested lines of objects converge on a vanishing point on the horizon. The first artist to make a systematic use of linear perspective was Masaccio, and its principles were set out by the architect Alberti in a book published in 1436. The use of linear perspective had a profound effect on the development of Western art and remained unchallenged until the 20th century. *Aerial perspective* is a way of suggesting the far distance in a landscape by using paler colors (sometimes tinged with blue), less pronounced tones, and vaguer forms.

Pop Art An art movement originating in both the USA and Britain in the 1950s and flourishing in the 1960s. Rejecting abstract art, Pop artists drew upon a wide range of images from popular consumer culture, such as advertising, comics, magazines, and pop music. Leading figures of Pop Art include Richard Hamilton, Andy Warhol, Jasper Johns,

and Roy Lichtenstein.

Post-Impressionism (also Neo-Impressionism) A general term for a range of trends that reacted against Impressionism during the period from the mid-1880s to the early 1900s. In general these trends concentrated on the formal elements of painting, color in particular, and on the need for a work of art to be expressive rather than representational. Major Post-Impressionists include Vincent van Gogh, Paul Gauguin, and Paul Cézanne. Post-Impressionism forms a link between Impressionism and Expressionism.

Romanticism A literary and artistic movement, originating in the late 18th century, that asserted the importance of subjective experience. Rejecting the order and rationality of Neoclassicism, Romanticism spread throughout Europe and took many forms; common to them all was a new emphasis on feeling and emotion. Artists associated with Romanticism include J.M.W. Turner, Caspar David Friedrich, and Théodore Géricault.

Secession One of several art groups founded around the turn of the century in Germany or Austria. The first Secession was founded in Berlin in 1892 by a group of artists who, rejecting the official exhibitions as old-fashioned, wanted to hold their own exhibitions. Their leading figure, Max Liebermann, was an advocate of Impressionism. A parallel Secession was created in

Munich in 1897 by Gustav Klimt; here Art Nouveau and Symbolism predominated. See Vienna Secession, below.

Symbolism A literary and artistic movement of the late 19th century. Reacting against materialism, Symbolists sought an art that dealt with spiritual needs: the purpose of art was not merely to depict the world, but to suggest or symbolize a higher reality beyond appearances. Their works stressed the importance of imagination, visions, and dreams.

Vanishing point In perspective, the point at which parallel lines seem to meet – for example, railroad tracks that appear to touch each other on the horizon at the vanishing point.

Vienna Secession A group of artists formed in Vienna in 1897 by Gustav Klimt and others; the most important of the various Secessions (see above). The styles embraced by the group included Impressionism, Symbolism, and Art Nouveau. The Vienna Secession led directly to the creation of the arts and crafts society, the Wiener Werkstätte (Vienna Workshop) in 1903. The Vienna Secession split in 1905 when Klimt, unhappy at the direction it was taking, left.

Watercolor A painting medium in which pigments are dissolved in water. As watercolor dries to a transparent finish, it can produce particularly light and delicate effects, and needs to be applied with great care.

Index

Acknowledgments

The publishers would like to thank the museums, archives, and photographers for permission to reproduce the illustrations and their friendly support in the creation of this book.

© Archiv für Kunst und Geschichte, Berlin: 8 t, 12 t l/t c/t r, 13 t l/t c/t r, 15 t l, 20 b, 21 t/b l, 23 t/b, 24 t, 27 t l, 35 b, 36 t, 38, 42 b, 53 t l, 54, 55 b (photo: Trumter), 57 t l, 65 b, 71 t, 72 t, 73, 77 t l, 79 l, 81 b, 82 t l/b; (photos: Erich Lessing) 5 b, 24 t, 49, 51 t, 65 t, 76, 81 t, 85

© Artothek, Peissenberg: (photos: Dr. Brandstätter) cover, 25 t/b, 27 t r, 39, 44 b, 46, 47 b r, 55 t, 64, 80 t r, 88 r; (photos: Christie's) 4 b r, 56; (photo: Bridgeman) 50

© Austrian Archives/ Christian Brandstätter, Vienna: 2, 4 b r, 7 t l, 12 b, 13 b, 17 t, 22, 29 t, 41 t r/t l, 42 t, 43, 44 t, 52 b, 53 t r/b l, 57 t r, 59, 60 t/b, 62 b, 66, 67 t r/t l, 68 b, 71 b, 77 b, 84 b, 87, back cover

© The Bridgeman Art Library, London: 5 t r/t l, 26, 30 b, 34 t, 37 b, 40, 47 t, 48 b, 51 b, 58 b, 61, 75, 78, 80 b r, 83

© Collections Comédie-Française, Paris: 18 l

© Egon Schiele Museum, Tulln: 9 b, 91 t l

© Courtesy of the Fogg Art Museum, Harvard University Art Museums, Gift for Special Uses Fund: Shelter Rock Foundation and Anonymous Donor: 74

© Courtesy Galerie St. Etienne, New York: 4 t r, 9 t l, 11 b, 14, 20 t, 21 b r, 29 b, 30 t r/t l, 31 l, 41 b, 63 t l, 77 b, 82 t r; (photos: Alessandra Comini Photo Archive) 10 c, 16 b, 31 r, 35 t l, 52 t, 57 b, 69 l, 79 r

© Graphische Sammlung Albertina, Vienna: 4 t l, 6, 7 t r, 8 b, 9 t r, 10 t, 15 t r, 16 t, 17 b, 18 r, 19 l, 25 c, 27 b, 28 t, 32, 34 b, 37 t, 47 b l, 53 b r, 62 t, 63 b, 67 b, 68 t, 70, 80 l, 89 b, 90 b

© Historisches Museum der Stadt Wien: 28 b, 35 t r, 36 b, 48 t, 69 r

© 1999 Kunsthaus Zurich. All rs reserved: 45

© Courtesy of Christian M. Nebehay, Vienna: 91 b

© Niederösterreichische Landesmuseum St. Pölten: 7 b, 10 b, 11 t

© Öffentliche Kunstsammlung Basel: 72 b (photo: Martin Bühler)

© Österreichische Nationalbibliothek Vienna: 63 t r

© Sammlung Dichand, Vienna: 33

© Victoria Schaffer, Vienna: 90 t

© Margherita Spiluttini, Vienna: 89 t

© Vatican Museums: 19 r

All other illustrations come from the institutions named in the captions or from the editor's archives. The editor has attempted to trace and attribute the copyright for all the works illustrated. Any other persons claiming copyright are requested to inform the publishers.

Key

t = top
c = center
r = right
l = left
b = below

Cover:
Mother and Child, 1910
Gouache and pencil on
paper
55.6 x 36.5 cm
Vienna, Historisches
Museum der Stadt Wien

Page 2:
Schiele in front of his picture
Meditation in the Forest,
photograph 1915

Back cover:
Schiele next to his picture
Encounters, photograph
1914

Imprint

© 1999 Könemann Verlagsgesellschaft mbH
Bonner Strasse 126, D-50968 Cologne

Editor: Peter Delius

Concept: Ludwig Könemann
Art director: Peter Feierabend
Cover design: Claudio Martinez
Editing of the original edition and layout: Alexandra Schaffer
Picture research: Jens Tewes, Kathleen Wünscher
Production: Mark Voges
Lithography: TIFF Digital Repro GmbH, Dortmund

Original title: Egon Schiele

© 1999 Könemann Verlagsgesellschaft mbH
Bonner Strasse 126, D-50968 Cologne

Translation from German: Christine Shuttleworth in
association with Goodfellow & Egan, Cambridge
Editing: Chris Murray in association with Goodfellow & Egan,
Cambridge
Typesetting: Goodfellow & Egan, Cambridge
Project management: Jackie Dobbyne for Goodfellow & Egan
Publishing Management, Cambridge, UK
Project coordination: Nadja Bremse
Production: Ursula Schümer
Printing and binding: Sing Cheong Printing Co., Ltd.

Printed in Hong Kong, China
ISBN 3-8290-2937-3

10 9 8 7 6 5 4 3 2 1